GHOSTS
of YORK

Rob Kirkup

AMBERLEY

Ghosts of York is dedicated to my good friends and ghost hunting teammates Tom Kirkup, Richard Stokoe, John Crozier, and Andrew Markwell. You've all been a joy throughout our entire York adventure, dedicated, enthusiastic, inventive, and top-notch company to boot. Thank you.

First published 2012

Amberley Publishing
The Hill, Stroud
Gloucestershire, GL5 4EP

www.amberleybooks.com

Copyright © Rob Kirkup 2012

The right of Rob Kirkup to be identified as the Author
of this work has been asserted in accordance with the
Copyrights, Designs and Patents Act 1988.

British Library Cataloguing in Publication Data.
A catalogue record for this book is available from the British Library.

ISBN 978 1 84868 236 8

Typeset in 10pt on 12pt Sabon.
Typesetting and Origination by Amberley Publishing.
Printed in the UK.

CONTENTS

FOREWORD

I met Rob back in 2005 when we started work at the same company together. It wasn't long before his enthusiasm towards the unexplained surfaced; I read through the various articles on his website, which documented the ghost hunts he had led, while sitting on the edge of my seat. When Rob told me the plans for this book and invited me to be part of the team I said yes without even giving it a thought.

I don't know what I was expecting. I've never really made up my mind one way or the other when it comes to ghosts and the paranormal. Surely there must be something real in it, or what is all the fuss about? But then, a quick search on the Internet reveals that Britain now has over four million CCTV cameras. Surely something would have been picked up on one of those by now? Perhaps we just aren't pointing them at the right places: cemeteries, clock towers, dungeons, etc.?

I dabble in a bit of Photoshop so I'm hard to sway when it comes to photographic evidence; nothing stands out as being particularly persuasive and there is a glut of information out there about double exposures and damaged film that makes the 'proof' even harder to believe. The same goes for electronic voice phenomena, or EVP; the elusive art of recording haunted places hoping to hear unspoken words on the tapes when they are listened to later, or listening to white noise. It's amazing what the human brain hears when it tries hard enough.

I sound pretty sceptical don't I? Well, I'm not one to waste my time on pointless endeavours so why did I instinctively jump at the chance to join Rob's team on this adventure through ghost-infested locations in and around York? On reflection I think it mainly came down to ignoring the books, movies and newspapers. It was about putting myself in a situation where I could experience the places and the feelings first-hand.

This was a journey of discovery. I like being able to explain things, which is why I love learning about science and engineering, but on this adventure I had a different goal, I wanted something to happen that left me completely blank when I tried to rationalise it. I wanted to be that person who had seen, or heard, or been touched by something from beyond the grave. I wanted a 'convincer'.

York is a magnificent setting for this personal quest for utter confusion; fantastically historic, architecturally beautiful and heart-warmingly quirky. York Minster is one of Britain's visual gems; the old cobbled streets of the Shambles contain some of Europe's oldest shops and are among the oldest, continually inhabited places in the world. The high student population means there is always music playing and people performing in the streets to pay their university fees. Moving through this vibrant cacophony on the

way to spend a bitter, dark night in a place reputedly haunted is odd to say the least. It brings a whole new perspective to the city.

Don't be fooled, this is not a book about ghosts. This book tries to answer a question that we all ask at some point: what happens after we die? This is one question we will all get an answer to. This is also a book about an epic, year-long journey shared by a group of good friends including all the baggage that comes with that: disagreements, joviality, scheduling problems, parking issues, traffic, music choices and (of course) eating.

Rob felt it was fitting for one of the team to write the foreword, given how it was a shared experience, so I gladly offered. I feel truly honoured being asked to take part and I wanted to thank him sincerely. I have learned a lot about myself, the other members of the team and about historic York. We have had amazing times, strange times and very scary times, but through the trials and tribulations we have grown as people. We now have our own stories to tell that will last us our lifetimes.

So what about the ghosts? I started out feeling sceptical but open-minded. I clung tightly to science and the rational. And now? Well, I can't possibly ruin the rest of the book for you, but it is safe to say that my attitude towards the paranormal is changed forever.

Richard Stokoe

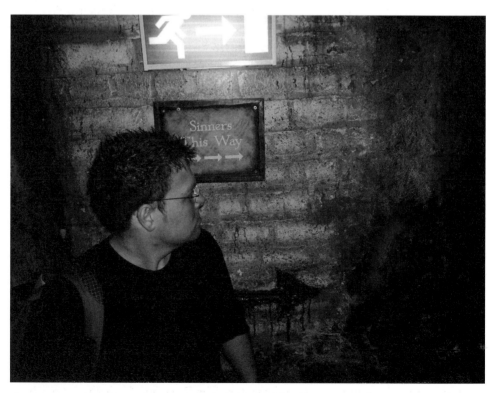

No turning back now! Rich on investigation at York Dungeon.

ACKNOWLEDGEMENTS

I'd like to begin by thanking my fellow ghost hunters: Tom Kirkup, Richard Stokoe, John Crozier, and Andrew Markwell. Without their enthusiasm, support, and friendship this book would most likely have never passed the initial idea phase. A special mention goes out to Rich for kindly agreeing to write the foreword. I asked him as he's an extremely talented writer in his own right and from the day I signed the contract to write this book I always envisaged it should be someone who'd shared in our adventure to write the piece. Thanks mate.

My heartfelt thanks go out to my family for their support throughout the writing of *Ghosts of York*; in particular my wife Jo for putting up with me spending so many nights away from home 'playing' *Ghostbusters* with my pals. Eternal thanks to my parents Tom and Emily for all their encouragement. I would also like to express my gratitude to my in-laws: Patricia and Michael, my brother-in-law, James, and Norman, Jo's granddad.

During the phase of narrowing down the vast array of haunted venues in York to just ten, local expert Rachel Lacy (www.ghostfindergeneral.co.uk) was absolutely brilliant and so knowledgeable. The team and I owe you a huge debt of gratitude, Rachel, for all your help.

Freelance Sound Engineer Jack Wiles (www.jackwiles.co.uk) was invaluable in helping with our EVP related queries, and I'd like to express my thanks to him for giving up his time to help our cause.

The owners and staff of the locations we investigated in this book could not possibly have been more helpful, and I'd like to thank everyone at the Dean Court Hotel, Grays Court, York County Council, Haunted (35 Stonegate), York Dungeon (Especially Krissi and Emily), Middlethorpe Hall Hotel, and the Golden Fleece. Our appreciation goes out to the brilliant people at Mysteria Paranormal Events (www.mysteriaparanormalevents.co.uk) who were kind enough to accommodate us on an organized public ghost hunt at York Guildhall. I'd also like to thank everyone at the National Railway Museum, and the guys from P.A.R(t) who were nice enough to allow us to join them at the museum to form a joint investigation.

We spent ten nights in York. The accommodation and hospitality we received from the guest houses and hotels that put us up really touched us all. Bar Convent on Nunnery Lane generously gave us rooms for six nights – thank you from the bottom of our hearts you were so welcoming. At the Cumbria House (www.cumbriahouse.com), Tom and Elaine were the ideal hosts, kind, warm, and genuinely enthused by our York ghost adventure. Thanks to the friendly staff at The Days Inn, Wetherby, who helped us during our stay.

The kind people at www.glow.co.uk were generous enough to donate the head torches that Tom and I wore throughout the book, and Olympus provided our recording equipment including the excellent Olympus LS-5 digital voice recorder. The public liability insurance we held for the investigations at Haunted and the Golden Fleece was through Insurelink (East Anglia) Limited.

The York Archaeological Trust were great too, when I contacted them tentatively about a location which we ultimately didn't investigate, they allowed us to visit the excellent Jorvik Viking Centre by way of supporting our time in York.

Last, but certainly not least, I would like to say a big thank you to everyone at Amberley Publishing – Sarah Parker and Tom Furby in particular – for the faith shown in me, and their support and guidance from day one.

INTRODUCTION

IN THE BEGINNING

In the summer of 1987 most eight-year-old boys growing up in Newcastle-upon-Tyne were making the most of those long, hot days that seem to never end; emulating their footballing heroes whilst kicking a ball around in the park with their boyhood pals, rummaging around nearby trees for a decent stick which they could use as a makeshift gun in a game of 'armies'; or if they were lucky enough to own the must-have gadget of the day – the Sinclair Spectrum +2. They might well have been sitting through a high-pitched whining noise for twenty minutes waiting for the cassette to load Chuckie Egg onto a 14-inch portable television.

I loved to pursue all of these boyhood pastimes; however, a large chunk of my time was taken up that particular summer as I dared to consider a question that would change my life from that point forward: Do ghosts exist?

A fairly deep question for someone so young, you might think, but my imagination had been captured on one particularly fateful visit to the small library in Fordley, the village in which I lived. My nana used to take Thomas, my younger brother, and I to the library once a week where we could loan up to three books each visit. I loved to read and although I was initially more than happy with the books in the children's section, I was always curious by the books the adults were reading in the 'grown-up' area; in particular the non-fiction books, which seemed so mysterious and forbidden. On one visit in the early summer of 1987, my curiosity had become so overpowering that I approached the librarian's desk and, barely tall enough to see over the desk, I said 'hello' to the lady stamping books behind the counter. She looked down at me, beamed a huge smile to me and asked how she could help. 'Am I allowed to borrow books from over there?' I asked, standing on my tiptoes and pointing. She looked towards the large non-fiction area and then back at me, she smiled again and said 'of course you can, if there's any books on higher shelves you need me to get down for you just let me know'.

I couldn't believe my luck, I was finally going to be able to get my hands on the books that the older children and grown-ups had been reading, and from that day forth I almost completely turned my back on the children's section. I scanned the shelves and felt more than a little underwhelmed by the books I saw – car mechanics, gardening, science. However, I then came across a thick hardback book with a tatty black spine with *The Encyclopedia of Ghosts and Spirits* printed along it. I carefully took this book, written by John and Anne Spencer, down from the shelf, and studied the cover. My eyes were wide with both fear and wonder. It was made up of six separate photographs, but it was the one right in the centre of the cover which drew my attention and made

me reconsider whether I actually wanted to open the well-thumbed tome and find out what lay within its yellowed pages. It depicted a fairly ordinary looking staircase, not dissimilar to the staircase in the house in which I lived, but this one had a ghostly white lady floating down it. That was my first exposure to the paranormal, and as I lost myself in the 400-odd pages of the book I knew that I wanted to find out as much as I possibly could about ghosts. Over that six-week summer holiday I loaned the same six books from the library over and over again, reading them repeatedly, studying the photographs at length, despite the fact that when the time came to go to bed I secretly struggled to sleep, lying awake in fear that perhaps the house I lived in could be haunted by ghosts just like the ones I'd seen and read about. However, I couldn't, and didn't want to, turn my back on the paranormal. I was hooked.

As the years passed I became even more passionate about the subject, building a collection of books to which I added regularly, asking for books for Christmas and birthdays. I also collected newspaper cuttings of reported ghostly activity from not only my native north-east, but the whole of the UK.

In October 2002, now aged twenty-three, I was working at the Inland Revenue, and it was here where a chance change of radio station would take my interest in the paranormal to the next level. The distinctive voice of the long serving and well known presenter of a local station's night-time show piped through the headphones of my Sony Walkman. I stopped working momentarily as something he said grabbed my attention.

> *Do you want to be part of this year's Halloween show? I will issue you the challenge of being sent to a truly terrifying, and extremely haunted location where you will conduct your very own investigation. If – or should that be when – something happens you'd call the show live on the hotline number and we'll get you straight on air. If you would like to be part of the year's biggest show then write in to the usual address explaining why you'd like to be involved and I'll select ten listeners who will be our on the spot investigators on the night of Halloween, the night on which 'they' walk amongst us.*

Never before had I considered actually pursuing the spectres that I'd spent the last fifteen years casually researching, but the very next morning I popped a letter in the post, realistically not expecting to hear anything back. However, come the evening of Halloween I found myself at Talkin Tarn, a lake in Cumbria, with three guys I'd met during my university days: Andy Markwell, John Crozier, and David 'Kenco' Henderson. In the previous month over twenty daytime visitors had been horrified to see the bloody apparition of a woman walk from the murky depths of the lake before simply fading away, and we were the four first-time ghost hunters tasked with the job of trying to make contact with her on the scariest night of the year.

That evening was a terrifying first foray into the world of paranormal investigation, and despite being a fairly uneventful evening it would become the first of many as I began to organise my own investigations all over the north-east, never actually forming a team as such, instead opting to invite friends along to join me. The reason I wanted to spend night after night in draughty old castles, pubs, and even a hairdresser's on one

occasion, was simple – I wanted my own undeniable, intangible proof to the question I'd asked myself almost daily since I was eight years old: Do ghosts exist?

Fast-forward to May 2010; I was sitting in a pub in the centre of Newcastle with Andy and John. By now I had over fifty investigations under my belt, and I'd even had several of my own books published on the subject of ghosts in the north-east. Neither of the guys had accompanied me on a paranormal investigation since Talkin Tarn, almost eight years earlier. However, I had a proposal for them. I had been toying with the idea of conducting a series of ghost hunts outside of the north-east: to be more precise I planned to take on ten of the most paranormally active locations in *the* most haunted city in the world, and I wanted to know if they wanted to a piece of the action? I didn't need to ask them twice, they both jumped at the chance to be involved. Within the week I'd signed a book deal with Amberley Publishing to document our adventure, and that fairly sketchy suggestion over a few drinks has since evolved into the very book that you hold in your hand.

Choosing York as the city upon which to base this book was a no-brainer. York is believed by many to be the most haunted city in the world, with Ghost Research Foundation International identifying over 500 separate recorded hauntings. What's more I absolutely adore the historic city of York and I'll never tire of visiting.

I first fell in love with the historic city aged around thirteen or fourteen when I went there for a day out with my parents. I was in awe of the historic buildings and the narrow, winding Snickelways of the city, and I'll never forget my first sight of the magnificent York Minster, the Gothic Cathedral which still impresses me to this very day. At the time I knew little of the Roman and Viking history that the city is steeped in, but my parents took my brother and me on the tour at the Jorvik Viking Centre and I was blown away. In fact, the tour had such a lasting impression on me that ten years later I'd enrol on an evening course at a college in North Tyneside and earn myself a qualification in Archaeology.

During that day out in York I was handed a number of flyers advertising ghost walks. I knew we'd not be able to go on one because they all seemed to begin at 7.00 p.m. or later and we'd be home by then. However, a few years later I visited York and took a tour called the Haunted Walk of York, and I was utterly enthralled by the stories I heard, hanging onto every single word that the tour guide had to tell us.

I set about putting a team together to join me. There are thousands of teams of paranormal investigators across the country, especially following the huge upturn in interest with the popularity of ghost hunting television programs such as *Most Haunted*. However, with this comes a potential pitfall: the size of these teams can be huge, with sometimes up to forty people on an investigation. This means that any creak, knock, or disembodied voice in the darkness may well be something paranormal, but in reality it is much more likely to be another member of the investigation team. I wanted to put together a small team of people I knew well. John Crozier and Andy Markwell, both of whom I'd known in excess of ten years, had both said they were on board, and I had already decided who else I was to approach. Tom Kirkup, my younger brother, who I've obviously known for all of his twenty-seven years, had been with me on the vast majority of my investigations. I suspected he would be up for it, and I was right. The final person I approached was a guy by the name of Richard Stokoe who I'd met in my

previous job. We'd both started working there on the same day five years ago and had been firm friends ever since, I dropped him a quick text and within only a few minutes his reply of 'yeah definitely' finalised the team. None of us are firm believers but we're all open-minded. In fact Andy, Tom and, to a lesser degree, Rich, are sceptical to the existence of ghosts, but I welcome this standpoint as it means we can scrutinise every happening together as a team, and if we encounter something that we can't rationalise then that might be the proof I've been searching for since I was eight years old.

The five of us would take on whatever Haunted York had to throw at us, but little did we know then that not all of us would make it through to the bitter end...

All photographs were taken by the author unless otherwise stated.

The author (right) sharing a joke with John (left) in an off-duty moment at the Cross Keys pub, York. (Photograph by Tom Kirkup)

CHAPTER ONE
NIGHT AT THE MUSEUM

National Railway Museum – 16/10/10

I checked my watch; it was 13.25 and I could barely contain my excitement. I paced the living room, peering out of the window every few seconds as I eagerly awaiting the arrival of my brother. This was much to the annoyance of Jo, my wife, as Holly, my Cocker Spaniel, danced around my feet mistakenly thinking she might be about to go out for 'walkies'. A little over ten minutes later, my younger brother Tom pulled up outside, late as always. I grabbed the bag I'd packed earlier in the day and headed outside to greet him.

We didn't have far to drive to pick up Andy, the next member of the team, as he lived only a few streets from me. As Andy put his backpack into the boot I noticed that it looked almost empty. He took a seat in the back (Tom had called 'shotgun' earlier in the week and so was in the passenger seat) and I turned to ask if he'd actually remembered to pack his bag. 'Yeah I've got a can of Diet Coke, my camera, and a clean pair of underpants.' He added, with a shrug, 'What else do I need?' Touché.

A short while later we reached John's flat and John approached the car wearing his trademark massive black coat. He was laden with two huge bags, one of which, he told us, was full of warm clothes for the night ahead, and the other was full of food and drink including a piping hot flask of Bovril. I pulled away and he began to reel off a long list of the things he had packed, I glanced in the rear-view mirror and Andy's face gave away his realisation that perhaps there may well have been one or two things he should have brought: a torch for example.

We met Rich, the fifth and final member of our crack ghost-hunting unit, in the Mill House pub car park just off the A1 at Washington and we were on our way to York; reputedly the most haunted city in Europe, a city so terrifying that it should be twinned with Jurassic Park. Well, we were almost on our way. Rich was struggling to get into the back of the car. For reasons known only to him, John refused to put his big bag of food and drink in the boot and instead wedged it between his legs. This meant Rich, who was sitting in the middle, was forced to half sit on the back seat and half on John's leg whilst swivelling his body to share a footwell with Andy. After ten minutes of manoeuvring into position Rich said that he was in and they were ready to go. I looked in the rear-view mirror and my entire back window was blocked out by Rich smiling back at me, appearing a foot taller than Andy and John either side of him because of his elevated position. We were now finally on our way, and as everyone chatted and laughed you could sense the excitement and anticipation for the first investigation of our York adventure – the National Railway Museum (NRM).

We arrived in York just after 4.00 p.m. and there'd been a real buzz from the lads during the journey, it was clear that everyone was just as excited as I was, and had been since the day I signed the contract to write this very book.

I had made arrangements for accommodation for the five of us at Bar Convent, the oldest living convent in England. There has been a convent on this site since 1686, and the current Georgian building dates from the 1760s. We entered and explained to the sister on reception who we were and that we were expected; within moments a gentleman appeared and said, 'Ah you're the ghost people aren't you?' The kindly sister who I had made our arrangements with came to meet us. She welcomed us, but was quick to make sure we were only too well aware that Bar Convent is most definitely not haunted.

We were shown to our rooms: Rich, Tom and Andy were staying in the Gods, and John and I were in a separate tower. We were keen to get out and explore York city centre so left our bags in our rooms and John and I made our way to the front entrance to the convent. We were joined shortly afterwards by Rich, Tom and Andy.

It was the perfect autumn day; dry with just the slightest of chills in the air, the unmistakable crunch underfoot of crisp fallen leaves in a kaleidoscope of reds, yellows, oranges, and browns. As afternoon began to give way to evening the sky over York was just as colourful, awash with every shade of blue, purple and pink imaginable. It was one of those truly breathtaking sunsets that make you feel good to be alive.

The walk only took around twenty minutes, and as we neared the city centre John told us he wanted to go to the York Hog Roast on Stonegate. Andy added that he needed to a torch. With John's need for meat in bread satisfied we headed to the nearby Lendal Cellars pub. It was pretty busy but we found a table for five in the atmospheric cellar which was formerly the Lord Mayor's wine cellar and for which the pub is named. The pub stands on the site of a thirteenth-century Augustinian friary, and throughout the years many discoveries have been made during the countless transformations and improvements to the building including a Roman well and walled-up human remains. As we had a few drinks and ate an evening meal our conversations bounced from topic to topic, with the subject of the evening ahead at the NRM regularly (and sometimes apprehensively) coming to the fore.

On our way back to the Convent after leaving Lendal Cellars just after 7.15 p.m. we passed the NRM. It was now completely in darkness, which made it appear an altogether more intimidating proposition than it had appeared during daylight hours with families merrily coming and going. Tom zipped his coat up as he commented that there was a definite chill in the air now, and it would only get colder during the night.

We arrived back at Bar Convent and headed off to our rooms arranging to meet at the front entrance at 8.15 p.m., a little over thirty minutes later. Our first appointment with the ghosts of York was 8.30 p.m.

A couple of the lads had said they might grab some sleep as it was likely we wouldn't see our beds again until around five in the morning. I decided to spend the time checking, and double checking, all of my equipment; putting new batteries in my torch (as well as a spare torch) and my digital voice recorder, and giving my digital camera an additional thirty minutes' charge.

At just after 8.10 p.m. there was a knock at my door. It was John, and he appeared prepared for a trek across the frozen wastes of the North Pole in his massive black

John (left) and Tom (right) at Lendal Cellars.

coat, gloves, woolly hat, and a gigantic rucksack on his back. As I zipped up my jacket and picked up my bag I passed comment on his arctic explorer getup. He told me, as we headed downstairs, that he was also wearing a thermal base layer, had hand-warmers in his pockets should he need them, and the aforementioned flask of Bovril to ward off the chill. When we stepped outside onto Blossom Street it was immediately apparent that John was kitted out perfectly as it was an extremely cold night, with the temperature a teeth-chattering zero degrees Celsius.

The others appeared five minutes later, Tom and Rich were wearing additional layers to counter the plummeting temperature, and Andy was wearing what had been wearing earlier. He may not have brought any additional clothing but thankfully he had already been wearing a fleece. It was a fairly short walk to the NRM so we arrived just after 8.30 p.m. I made a call to our host for the evening, Tom Griffin, the security manager at the museum. He was already on-site so came to meet us and show us inside. As well as having worked at the NRM for over six years, Tom is fascinated by the paranormal, regularly investigating locations across the north with his team. When I initially contacted the NRM much earlier in the year to enquire as to the possibility of carrying out a ghost hunt at the museum, Tom kindly contacted me explaining his role at the museum and offering us the chance to conduct a joint investigation with him and the other five members of his team; The Paranormal Activity Research team, or P.A.R(t) for short.

Tom led us to the staff meeting room which was to be our base for the evening. It appeared we were almost the last to arrive, as the room was a hive of activity with people setting up video cameras, laptops, and voice recorders, and someone making cups of tea and coffee. Everyone acknowledged us, taking a moment out of their meticulous preparation for the night ahead to welcome the new faces entering the room. There were handshakes and greetings all around, as well as offers of a hot drink. This warm welcome immediately put us at ease.

There were half a dozen empty seats scattered around the large table that dominated the room, so we took the free seats in amongst the others. Over the next fifteen minutes we had the opportunity to become acquainted the other members of P.A.R(t): Tony Horner,

The team approach the NRM.

Duane Ellis, Steve Garnett, and Mark Tempest. They explained that the final member of the team was on his way and should be with us soon. We were also introduced to Harvey and Youssef, television producers who would be filming the night's proceedings as they were in talks with the P.A.R(t) guys about a potential television programme. Just after 9.00 p.m. Tom suggested he give us a tour of the museum with the lights on so we will have a better idea of the layout of the buildings once the investigation begins. He said that he would fill us in on the paranormal activity reported by visitors and members of staff, as well as happenings that he and his team have experienced on their many previous investigations of the NRM. Tom also made us aware that at this point that there are two security guards on duty in the museum overnight – one in the control room and one patrolling – and that he would have radio contact with them both at all times.

The twelve of us stepped, one by one, through a door which took us out of the staff area and into Station Hall, a large recreated period station comparable in size to a football field. Housing a number of trains from a bygone age, including an exhibition of royal trains dating between 1840 and 1940, it really is a Mecca for rail enthusiasts. The lads and I had visited York a number of weeks earlier and carried out a reconnaissance visit to the popular museum during regular opening hours, and even on a busy day, with visitors enjoying the train exhibits and having lunch in the restaurant, I found the Station Hall, with large, echoey open spaces and eerie low lighting, to be an extremely atmospheric part of the building that just didn't feel quite right.

Tom told us, as we all listened on intently, that the hall is extremely active, with the spirit of an unknown lady having been seen on a number of occasions. During one P.A.R(t) investigation Tony spotted the figure of a woman walking through the open area beyond the restaurant, he watched her for a few seconds moving silently through the museum before shining his torch on her, but the moment the beam of his torch hit her, she vanished. A regularly reported phenomenon throughout the hall is the disembodied whistling of a merry tune, as if someone is cheerily going about their day.

Tom led us to a blue-coloured carriage which he told us was a Wagon H. Lees & Sons. It is believed that, although there is no evidence to prove it to be the case, during

the Second World War German officers ran it as a mobile brothel. There have been many reports by visitors and staff of banging coming from within the carriage when it's been empty. During investigations the P.A.R(t) guys have had good results with knocking seeming to come in direct response to questions.

One evening Tom was alone in Station Hall and heard footsteps walking behind him. He stopped but the footsteps continued. He turned around to see who was there and they stopped immediately. On another evening on an investigation, Tom was in the same area when he saw the figure of a man ahead of him. He could see the figure clearly in his torchlight; he was wearing brown trousers in a tight belt, a white shirt with no collar and the sleeves rolled up to the elbow. He simply faded away before Tom's eyes. The team investigated the area but there was no sign of the man, however the spot in which the phantom figure had vanished was 'charged up' with static energy.

We moved out of Station Hall and headed towards the gift shop and front entrance, Tom led the way, but to our surprise he stopped outside of the visitor toilets. He explained that the ladies' toilets were apparently haunted. I looked at Andy stood next to me, and he looked back at me, neither of us were sure if Tom was being serious or if this was some kind of pre-planned wind-up for the Geordie new boys. However, as Tom continued to speak it was obvious he was being completely straight with us. The entity said to reside within the toilets has been nicknamed 'Paul'. No one is sure who he was in life, his relationship with the museum, or why he opts to lurk within the ladies' lavatories. Paul is a very powerful, malevolent spirit, and on previous vigils he has responded directly to challenges to display what he is capable of by touching people, and even violently opening and closing toilet cubicle doors.

So dangerous is this spirit that women have actually been attacked and hurt by him; a member of staff was washing her hands whilst talking to a colleague and she began to make fun of the supposed ghost, at that precise moment something grabbed her hair and pulled it incredibly hard, her friend saw her head jerk back as she let out a panicked scream for help. They fled the pandemonium in seconds.

Tom told us that an unrelated phantom, a tall man wearing a dark suit and top hat, has been seen in the corridor between the gift shop and the entrance to Station Hall. The gift shop itself was the victim of poltergeist activity in the early hours one morning when a security guard on patrol walked through the shop, into Station Hall, and then five minutes later walked back through the gift shop to find that a rack of postcards had been thrown all over the floor. Rich asked if the incident was captured on CCTV, but as we could see once Tom pointed it out, though there is CCTV in the shop, it does not point in the correct direction to have recorded anything.

The next leg of Tom's terrifying tour took us to the Great Hall, and within only a few minutes we had an unexpected result. Our investigation hadn't even gotten underway properly yet – heck, the lights were still on – but our very own Rich Stokoe had an experience so powerful and so bizarre that it made him reconsider his position as a self-confessed 'probably sceptic'. I'll let Rich explain what happened:

Once we had met Tom and his team, he took us on a quick look around the museum
so we could get our bearings and wouldn't hurt ourselves later once security turned
the lights off for the night. The thought of six hours roaming through vintage train

carriages and ancient railway platforms in the pitch black didn't so much fill me with fear; instead I had a horrible feeling of impending chronic boredom. Thankfully, my first experience happened during the introductory tour itself, only five minutes after arriving at the Great Hall.

The Great Hall is a modern building with contemporary air conditioning and lighting, there is the chopped-off front of a retired Eurostar train and a railway bridge exhibit – hardly the stuff great ghost stories are made of. I was about to be proved wrong.

Tom took us to a point between an old Travelling Post Office (TPO) carriage and the railway bridge and pointed at the carriage, he explained that during a previous overnight vigil a medium had identified the spirit of a man named George in there, and we would go in there soon, but first, Tom took us up the stairs to the railway bridge.

I politely let everybody else go first and followed like the tail of the dog. As I reached the top of the stairs to the subtly arched bridge, I noticed that some of Tom's team had already started descending the steps on the other side and were heading towards the post office carriage. I was a little disappointed that they were going to have some fun in a haunted carriage while we were stuck on some dull bridge like a bunch of trainspotters awaiting a particularly rare brand of locomotive. And that's when it happened ...

All of a sudden I was overtaken by an incredible sense of panic. My heard started pounding in my chest and I started to shake. Tom had said earlier that if we saw, heard or felt anything strange to speak up, so I did. Reluctantly ... Nobody wants to be the hypochondriac ghost hunter who whinges about every draught or blast of cold air from the air conditioning, but this was very odd.

Once I had told him of my symptoms he beckoned me closer to where he was standing and I moved further onto the bridge. The panic stopped. Instead I felt warm, comfortable and very, very calm – noticeably super-placid. How peculiar. Things were about to get weirder.

'Somebody jumped to their death off this bridge,' said Tom.

I'll not deny that this scared the hell out of me. He went on to say that a man, who had molested a child and couldn't live with what he had done, committed suicide by leaping from the bridge when it was operation into the path of an oncoming train. After he said this, I returned to where I was standing originally and the panic set in again. Tom suggested we leave the bridge for now and I was only too happy to oblige.

I didn't experience anything else on our initial tour around the NRM, but a little later I got talking to Duane, one of Tom's fellow ghost hunters, and another spine-chilling revelation came about. It turned out that during the tour Tony had got to the top of the bridge, immediately become panicky and headed off the other side. That's why we had seen them earlier abandoning the bridge and heading towards the TPO. Tony, it turned out, had experienced something similar to me. This was exciting; corroboration is the gold dust of paranormal investigation!

Tom took us over to the Travelling Post Office carriage, which he had pointed out when we had entered the Great Hall, and we joined some of the P.A.R(t) guys who were already inside. The TPOs were used throughout the nineteenth century as a means of postal clerks sorting mail *en route* to speed up delivery. Tom told us that the medium

The fairly inconspicuous railway bridge upon which Rich was overcome with panic. (Photograph taken Christmas 2010)

David Wells, formerly of *Most Haunted* fame, visited the NRM and was drawn to this relatively inconspicuous carriage. David had said that there was a spirit named George on the carriage who in life was a postal clerk and to this day still goes about his daily duties. George is aware of people visiting 'his place of work', but takes such pride in his work that he simply continues to sort mail.

David appears to not only have made contact with one of the museum's most mysterious, lesser-known phantoms, but also finally provided a name for the spirit. There have been two extremely vivid, completely independent, reported encounters with George since the museum opened in 1975 that Tom is aware of; however, they've never been documented on the internet or in print, until now.

The first known sighting of George was made in the mid-1980s, a new member of staff joined the security team and a few weeks later his wife and child came to visit the museum. That evening his wife told him that although they'd had a really good day out, their child had found the mannequin in the TPO a little scary. He thought this was odd as he knew that there are mannequins in some of the carriages in Station Hall, but hadn't seen any in the Great Hall. However, being fairly new to the job he dismissed it as most likely an oversight on his part. The next day on his rounds, he was passing through the Great Hall and took the opportunity to peek inside the TPO, but there were no mannequins inside. His wife and child had both clearly seen a man sitting perfectly still and described him sat on one of the stools, smoking a pipe and wearing a grey suit with dark hair and a full beard.

In the early 1990s the same member of the security team was passing through the Great Hall when a female visitor to the NRM approached him in a state of urgency and said, 'Do you know that carriage is haunted?' She pointed at the TPO, 'there's something in there right now and it's a ghost'. The lady was with her husband who was hanging back slightly from the conversation and seemed more than a little embarrassed by his wife's bold claims. The lady led the member of staff into the TPO; her husband followed reluctantly a few moments later. Neither of the men could see anything, but she was adamant there was

The Travelling
Post Office.
(Photograph
taken
Christmas
2010)

a man sitting on one of the stools. She said he was wearing a grey uniform, had a full thick beard and was smoking a pipe. The member of security staff was suddenly rocked by a chill passing through him as he recalled his own wife's experience, which sounded almost identical. A curator of the museum was passing and he called her over and explained the lady's story to her. The curator told the woman that it was unlikely there could be a ghost fitting that description on the TPO as staff weren't allowed to smoke on the carriages. Tom went on to tell us that research has since revealed that in the very early years of the first TPOs coming into operation they actually were allowed to smoke.

Although these are the only reported sightings of the full spectral apparition of George that we're aware of, there may be many others where visitors have mistakenly passed it off as being a very lifelike mannequin.

We left the TPO and Tom guided us to the rear of the Great Hall where he told us of a former member of P.A.R(t) who conducted a solo vigil in this area. After no more than a few minutes she heard the footsteps of someone approach her from behind. Assuming it to be a teammate coming to join her she turned to talk to them, but she wasn't prepared for what actually stood before her. She described the see-through figure of a young woman wearing a blue shirt. It shook her up so much that not only did she vow to never set foot inside the NRM again, but that very night she left the team and turned her back on the paranormal altogether.

That rather stark warning of what the NRM can be capable of after dark brought Tom's tour to a close, and as we headed back to base I couldn't wait to get the lights turned off and see what the museum may have in store for us once our investigation got underway.

When we arrived back at base, Graham Ramsden, the latecomer from Tom's team, was waiting to greet us. Graham introduced himself as the team's parapsychologist as he shook me by the hand. We all took a seat around the table and Graham handed everyone a printed sheet of paper, I scrutinised the text as Graham explained that what he'd given

us was a questionnaire to establish the level of stress we had in our lives, with questions such as 'Have you recently lost a job or been made redundant?' and 'Have you had a family member or close friend pass away in the last twelve months?' Graham told us that people under a large amount of pressure or struggling with grief can experience sights and sounds brought about by their mental state, rather than anything paranormal. Each question carried a weighted score, and a score of 150 or more would result in a 75 per cent chance of this being the case, and scores of over 300 would mean there was a 90 per cent chance. We all scored well below 100, which pleased Graham as it meant none of us would present a possible risk to the validity of any experiences once the investigation began, and the time for us to get the lights turned out and get our ghost hunt underway was finally here.

I checked my watch and it was 10.10 p.m. We split up into two teams and agreed to meet back at base at 11.00 p.m. Tom radioed through to the security control room and asked for the lights to be switched off and then joined myself, Andy, Duane, Mark, and Youssef, and we headed for Station Hall. Rich, Tom and John joined Graham, Tony, Steve and Harvey to make up the second team and they headed to a room we hadn't visited on our tour but Tom had pointed out briefly as we had passed; the Archives.

The six of us sat on the steps next to the Royal Carriages, I hung my voice recorder from one of the handles of the carriage and clicked the record button. The reason for doing this was twofold; if we were to hear anything unusual, hopefully I would have recorded it so we could study it more carefully back at base or, if necessary, I could review it on my laptop when I get home. The second reason is that I was hoping to capture Electronic Voice Phenomena (EVP) – electronically generated voices captured on electronic recording devices which cannot be heard by the human ear in the actual environment in which they are recorded until the recording is played back. Sceptics have given the explanation that these voices are more likely to be static or stray radio broadcasts than actual ghosts making contact, but with the huge advances in recording technology, especially in recent years, digital voice recorders with the ability to record in exceptional quality are relatively inexpensive and the crystal clear sound quality makes it a lot more difficult to debunk some of the EVPs being captured.

An alternative form of EVP we plan to explore at a later venue is 'white noise' – tuning a television or radio into the static between occupied channels or stations. It is said that spirits are able to reach out and make contact with us on these unused frequencies.

Duane also placed his recorder nearby and we all sat in silence in the pitch-black Station Hall. As the minutes ticked by, I listened intently for something, anything, out of the ordinary, and I realised that I don't recall ever experiencing such silence such as I was now. There was no sound at all, no constant hum of the air conditioning, no traffic noises from outside, we'd heard fireworks going off as we walked to the NRM earlier but I couldn't hear anything now – the only sound I could hear was the sound of my own heart beating, and it beat faster in my chest as I anxiously waited to see what was going to happen. I wouldn't have long to wait.

The silence was suddenly broken by a voice coming out of the darkness to my left, making me jump; it was Mark excitedly asking if anyone else had just heard a voice. A torch clicked on and Duane and Youssef confirmed that they too had heard the voice, which they both described as a very deep, male voice. Mark agreed that this had been what he'd heard and it sounded like it was coming from open area at the far end of

the hall near to the restaurant. I turned to Andy, wondering how on earth I hadn't heard it too, and asked what he had heard but he said he'd not heard anything. Tom hadn't heard it either, but with half of our group hearing something we had a lead and relocated to the area the voice had appeared to come from. Tom asked out for anything that may be with us to make itself known, but five minutes passed with no response so we agreed a different approach was needed. Duane suggested a séance around one of the tables in the restaurant, we all agreed it was a good idea so Tom borrowed a glass and Tom, Duane, Mark and I sat around the table. Youssef was filming the séance, and Andy said that he was going to go and bravely spend some time quietly alone back near the Royal carriages for ten minutes or so.

By the light of one torch the four of us lightly placed the tips of our index fingers on the bottom of the upturned glass and Tom began to ask for any spirits present to use our energies to move the glass. We all focussed on the glass expectantly as Tom continued to ask for the co-operation of whoever it was that Mark, Duane and Youssef had heard speak only ten minutes earlier; however, if someone or something was lurking in the darkness of Station Hall it wasn't playing ball, and we brought the séance to a close ten minutes later with no success. It was approaching 11.00 p.m. so the other guys headed back to base, while I went to retrieve Andy from his solo vigil. Andy said he'd sadly experienced nothing, but we chatted optimistically as we went to join the others. The night was still young and we had plenty more locations ahead of us.

Andy and I were the last to arrive at base and we quickly learned that the other team had drawn a blank down in the Archives, although when I got chatting to Rich he told me that he'd found it extremely unnerving and very, very, very dark – in fact the darkest darkness he'd ever experienced. We had a drink and John tucked into a Kit Kat Chunky as we discussed our next locations. There was a slight change to the teams with Graham and Mark trading places. The other team were interested on following

Andy
investigates
Station Hall.

up on the voice heard by some of our number in Station Hall, and our team decided to see if we could reason with Paul, the potentially dangerous spirit of the ladies' toilets.

When we entered the ladies' toilets it didn't feel quite right, and I don't mean in a spooky ghostly sense. When I looked at the 'ladies' sign on the door as it fell shut behind me I felt like we were somewhere we shouldn't be. It was a fairly spacious room with clean white walls, toilet cubicles, sinks; a well-kept public toilet. We spread ourselves out around the room: Andy stood at the far end of the room next to a bin with a sticker on the lid that read 'Nappy Bin', Tom stood against the door we'd just come through, Youssef stood with his back to the door of the first cubicle, and Duane, Graham and I stood with our backs to the counter with the sinks built into them. I passed comment to Tom that there was quite a lot of light coming in through the window, and he explained that unfortunately there was an emergency light positioned on the wall opposite the toilets which was one of the few lights in the museum that had to remain switched on at all times.

Graham asked for Paul to make himself known to us as the other five of us stood in silence, scanning the room for any sign of movement. Tom moved further into the room and then a moment later suddenly span on his heels, saying he'd seen the shadow of a man pass the door heading towards Station Hall, breaking the light coming through the small round window. No one else had seen it, but none of us were facing in the direction of the door. Andy suggested it could have been one of the other team that might have popped to the gent's toilet next door, and I added that it may have been the member of security on patrol. Tom radioed through to Tony in the other team who confirmed that all seven of their number were present and hadn't left Station Hall. Tom then contacted security who advised that the security guard on patrol was currently in the Great Hall and hadn't been in the area in over an hour. We were buoyed by this result and Graham eagerly continued asking for Paul to give us some kind of a sign that he was amongst us. There was no response, so Graham changed his approach and tried challenging Paul to demonstrate

Andy in the
ladies' toilets.

his power to us, somehow prove to us that he didn't just prey upon women. At that moment I felt a strong breeze blow across my face, and Graham, who was stood next to me, said that he felt it too. Graham tried to rationalise and establish where it could have originated, there was air conditioning in the toilets, but we quickly determined that this was not switched on. Graham tried to get through to Paul again asking him to affect us in some other way. I suddenly came down with a really bad headache and began to feel a little dizzy and disoriented. The more Graham asked, the worse my headache became. I was going to speak up, but before I could Tom unexpectedly shouted 'stop!'

Tom had mentioned to me earlier in the evening that he is sensitive to spirits, and he explained the reason for his sudden outburst. He said that he felt angry as Graham continued to challenge Paul, and the more Graham spoke the angrier Tom got. I realised that, as I listened, amazed, to what Tom had to say, my headache had vanished – this was all becoming rather weird, but unfortunately the time had come to head back to base to meet the other team.

As we entered the staff room the other team were already back and were excitedly huddled around a television in the corner of the room to which they were connected the night vision video camera which Tony had been operating during their vigil. I shouted over to John to find out what all the commotion was about, he came over and told me that they'd spent the last forty-five minutes on the Wagon H. Lees & Sons carriage in Station Hall which was believed was used as a brothel during the Second World War. They'd heard a tap on the carriage window next to where they were sat so Rich, who speaks German, asked questions in a language that the spirit of German officers may understand. They then captured the most amazing orbs on video (orbs are believed by many paranormal investigators to be a manifestation of spirit, sometimes called 'energy balls') so were connecting the video camera to the television to study them in a little more detail to see if it could be eliminated by being some form of natural phenomena, perhaps an insect flying past catching the light from the camera, or a speck of dust.

At just after midnight our team headed to the Great Hall to investigate the TPO, a location that I personally had been eager to visit since first contacting the NRM to make arrangements for this very evening. As we left the base a couple of the P.A.R(t) guys shouted over to let us know that the orbs on the recording unfortunately seemed to be nothing otherworldly and were 'probably just dust'. They added that they were going to spend some time in the ladies' toilets and we'd meet up again in an hour. At hearing this Graham decided to leave our group and join the others as his interest had been piqued by Tom's reaction to his questioning, and he was keen to see if he could provoke a similar reaction from one of the members of the other group who were currently unaware of the earlier incident.

Upon the five of us entering the Great Hall the first thing that struck me was how much more menacing the vast building appeared with the lights switched off. The TPO is to the right of the entrance and as we approached it, with me bringing up the rear, I had an uneasy feeling of being watched; this led to me constantly turning around and scanning the area with my torch. The sensation was so strong, so real, that I almost expected to catch a glimpse of someone, or something, moving in the darkness.

Once inside the TPO, Andy, Youssef, Duane and I sat upon the four stools at the mail sorting area and Tom positioned himself near the entrance, recording us with a

night vision video camera. Duane suggested we should sort through the mail, as on previous investigations it had produced some good results to attempt to make contact with George while appearing to be doing the same job that he had done daily now in that very carriage for over 200 years. I clicked record on my voice recorder, placed it upon the counter, and began to sort through the letters, as did the other guys. This time I led the attempts to make contact with George. I asked my first question; 'If you're present George, can you let us know you're here with us?' and Andy and Duane simultaneously said they heard a noise which they both described as sounding like a man sighing. Andy added that he had heard it really close to his left ear; however, I was sitting to his left and I hadn't heard anything. I continued to ask questions as we sorted through the mail but our remaining time at the TPO passed without any response.

Before leaving we left the video camera locked-off, meaning we would leave it recording unmanned, fixed upon one continuous shot, and we'd scattered a couple of letters on the stools and on the floor, in the hope that George, a man obviously proud of his work and of his carriage, would tidy up and we would capture it on camera.

I returned back to base with the other guys and felt a little despondent at the lack of conclusive activity so far, although I know only too well that paranormal investigations can often be a waiting game and patience is must-have attribute for anyone considering taking up ghost hunting seriously. The other group returned shortly afterwards and they told us that they'd all felt a kind of swirling breeze moving around the toilets as John attempted to communicate with Paul, but the unusual breeze stopped as quickly as it had begun.

With 1.00 a.m. fast approaching, Youssef and Harvey said their goodbyes as they had to hit the road for a long drive home. Mark rejoined Tom, Andy, Duane and I to even the numbers out, leaving Rich, John, Tom, Tony, Steve, and Graham to make up the other team.

Our next location was to be the Archives deep beneath ground, a large air-conditioned room used to safely store the museum's treasures that aren't currently

Inside the Travelling Post Office.

on display. We made our way by torchlight to the furthest area of the room, an open area with a couple of seats. Mark told Andy and me about previous investigations and the phenomena experienced attributed to a spirit they call Daniel, who seemed to be drawn to the Archives as he was attached to one of the artefacts but no one was sure which piece specifically. Daniel manifests himself in the form of footsteps, breathing, lightly touching people, and on one particularly terrifying vigil, possession.

The guys from P.A.R(t) had been in the Archive in the early hours one morning sitting in silence, in utter darkness, the only light coming from a flashing LED on the night vision video camera that Mark was operating. A rustling sound was heard coming from back towards to the door of the room, so Mark swung around to see what the video camera could pick up, the other guys remained silent in the hope of the sound developing into something more substantial. A few minutes passed without incident, so Mark turned around to get the fright of his life: Tom had approached him when his back had been turned and was now nose to nose with him. However, he almost didn't look like Tom; his face was contorted in what seemed to be pure anger and hatred. A couple of the other members had to physically drag Tom away from Mark and talk to him quietly and calmly until he appeared to snap out of it, at which point he had no recollection of what had happened except that the last thing he remember was feeling intense rage like he had never felt before.

We turned our torches out and I immediately knew what Rich had meant earlier when he described the room as being very, very, very dark, I waved my hand right in front of my face and couldn't see a thing. We'd not even begun to attempt to communicate with Daniel, or any other spirits residing in the Archives, when Andy heard footsteps walk behind him. He decided to relocate to the area where the footsteps seemed to be coming from, amongst racks of the museum's artefacts. Duane asked out loud 'If you're here amongst us Daniel can you make your presence known?' With this we all heard a rustling sound which had appeared to come from the area Andy had moved to, but Andy was adamant he hadn't moved or brushed against anything. We all joined Andy in this central area and made sure we were standing clear of one another as it was a fairly confined space. Duane continued to ask out loud for Daniel to give us a sign he was with us. Five minutes or so passed and all was quiet, until Duane unexpectedly blurted out 'What was that?' He then turned his head torch on, blinding me and Mark who were stood opposite him. Duane explained that he had felt someone stroke his arm, but as he looked around the group it was apparent that we were all too far from him for it to have been one of us. He left his head torch on as he held out his arms and asked for the spirit to touch his arm again, nothing touched Duane's arm in response to his request, but Mark turned around quickly, looking behind him. Duane asked what Mark had seen or heard, and he answered that he'd heard footsteps hurriedly pass behind him along to narrow walkway from the door towards the area of the room at the far end that we'd been in not ten minutes earlier. To all five of us it seemed obvious that we were not alone.

We spent another thirty minutes in the Archives, but after the footsteps Mark had heard the room seemed to settle down and we didn't experience anything more.

We returned to base and I personally felt really enthused by the happenings down in the Archives: two different people had clearly heard footsteps when we were all stood perfectly still, and we were so far below ground it could not be attributed to any form

of natural source from outside, nor could it have been the other team as they weren't even in the same building as us as they'd been in the Great Hall. For Rich this was a much anticipated return to the railway bridge that had caused both he and Tony such panic earlier in the evening.

It was five hours before we dared to return to the bridge. This time Tony and I led the way with Graham, the parapsychologist from Tom's team, our Tom, John, and Steve. As I climbed the stairs to the bridge for the second time that night, the parapsychologist asked me to stand where I was when I first felt strange. I did so and he started to rub his chin.

'We've had reports by people saying they've seen an apparition exactly where you're standing,' he said.

It was like being in a movie where a character suddenly turns out to have magical telepathic powers but that sort of thing doesn't happen to me, I'm quite boringly normal, so I was struggling to believe any of it was actually happening.

Graham was exactly what every ghost hunt needs – a rational, level-headed thinker. We began to try and debunk my earlier experience and I was hoping more than anybody that it could easily be explained. He started by ascending the steps himself and seeing if he felt any change in camber underfoot, perhaps a confused inner ear could have induced a feeling of imbalance and disorientation leading to a panic attack. However, nothing was obviously wrong with the bridge and if there had been we reckoned more of the dozen people who had climbed those same stairs earlier would have been affected too.

Next we ran a laser thermometer along the handrail from the centre of the bridge (where I felt calmer) to the top of the stairs (where I still felt strange). There was a point very close to the top of the stairs where the temperature suddenly dropped from 24°C to 17°C. Graham surveyed the air conditioning vents and agreed that they weren't close enough to cause that contrast in temperature. The closest we could get to an explanation was residual heat from somebody resting their arm against the handrail, but even then it was hit-and-miss when we tried to reproduce it – and even so, it had been five hours since anybody had been near the bridge.

Next, we set up a 'C-cell' battery on a piece of paper on the second-from-top step and drew around it so we would know if it had moved. We asked any spirits nearby to move the battery, or knock so we would know they were there. Half an hour passed without a reply, but during this time Tony and I had ascended and descended the stairs many times to try and get to know the bridge's effects on us. We both agreed that the energy, or spirit or whatever it was, was fading away and was affecting us less now.

It was obvious at the time to think that we were using up the energy. Writing those words now is very strange. I'm no expert in the paranormal – that's Rob's job – I was just along for ride, and yet at that time it was very clear to a sceptic amateur that the energy was diminishing.

After an hour on the bridge I felt nothing. The contrast between the area that made me panic and the area where I felt incredibly calm had vanished too. It was all just incredibly normal and boring again. However, with one final vigil ahead of us I wasn't quite finished giving Derek Acorah a run for his money.

Left to right: Back at base, John, Rich and Tom review photographs and recordings before heading back out into the museum for their final vigil.

Back at base the eleven of us took an extended break as the evening had been extremely frantic. This, combined with the time being after 2.00 a.m., was all beginning to take its toll. Everyone refuelled with cups of hot coffee and energy drinks as we took the opportunity to get to know each other a little better and share stories and experiences from previous investigations. Tony asked to know more about the book I was working on and we discussed the nine other locations across York that my team and I would visit over the next year and a bit. The conversation eventually moved back to the investigation at hand, and with enough time left for one more vigil each, we decided that Graham and Steve would come with our team and spend some time in the Wagon H. Lees & Sons carriage that the group had investigated much earlier. The other group, which by now consisted only of Rich, Tom, John and Tony, would also be in the Station Hall, but they would be over by the Royal Carriages.

At 2.50 a.m. we headed out into the museum for one final throw of the dice. I had high hopes as we carefully climbed aboard the Wagon H. Lees & Sons carriage. We passed through the carriage, creepy mannequins at every turn, and I sat down in an empty compartment on my own. Pressing record on my voice recorder, I put it on the seat next to me. The other guys sat in the next compartment along. Duane immediately tried to stir up some activity by speaking out, asking for anyone there with us to let us know that they were there. This was closely followed by a knock at the window, seemingly in response to Duane's question. I found this particularly interestingly as the other group had heard a knock at the window when they investigated this location earlier. Further questions by Duane disappointingly drew a blank, so he changed his approach and challenged the spirits to prove they existed and were powerful enough to move something or touch someone. Duane stopped talking and we heard a voice shouting loudly just outside the carriage. We all sat bolt upright and looked at each other in a way that said 'Did you just hear that?' Tom tried to radio through to the other team to establish their current location and ask if they'd heard the same thing;

however, there was no response. Mark said that he would head across to the other team, while we would resume our attempts to communicate with the spirits of this historic carriage.

Mark approached the other group, but with them having no idea that he was on his way to see them, what they saw emerging out of the blackness towards them was a dark man-sized figure, and all four stood there dumfounded believing what they were seeing to be a ghost. John turned on his torch and rather bravely approached the figure saying 'hello, who are you, can you tell us your name?' to which the mysterious shadowy creature clicked on his head torch and replied 'it's me you daft bastards!'

Meanwhile back on the carriage our continued attempts to coax some form of activity had failed, with the only notable occurrence being the sound of a train speeding past the museum. Our investigation had drawn to an end and we headed back to base for the final time. As we walked up the stairs Andy said to me quietly, 'Why did everyone seem so puzzled by the sound of a train? We're right next to York station and it was clearly the sound of an electric class 92 loco. I didn't want to say anything at the time as it would have made me seem a little bit nerdy to the others'.

The other team arrived back at base shortly after us, and as I chatted with Rich it appeared that aside from their 'ghost' sighting which turned out to be Mark, they had also had some genuine experiences, with Rich seeming to connect with the spirit of a man who lost his life in a tragic accident.

The very last place I went was the Royal Carriages, with Rob's brother, Tom, John and Tony.

'As we walk up here see if you feel anything or see anything. This is the most active area,' said Tony as we walked the platform between the Royal carriages towering overhead (it's amazing how tall trains are when you don't have a few feet of concrete platform to stand on).

Onboard the carriage used as a mobile brothel during the Second World War.

As we walked past one carriage I started to feel strange again but the feeling went as I reached the end of it. Suddenly, though, the feeling came back as we approached the end of one of Queen Victoria's carriages; I felt like I was being watched from where the driver would have sat. We continued along the rest of the carriages then headed back. I confessed to feeling strange in two places on the walk up and wanted to see if it happened again before I mentioned exactly where to John, Tom and Tony.

Walking past the driver compartment on Queen Victoria's carriage I felt watched again and mentioned it to Tony, who had significantly more experience and knowledge of the events around there.

'During Queen Victoria's reign, they were shunting this carriage with another – that's what they call it when they join two trains together. What they normally do is get the two trains next to each other and stop and then somebody steps in and connects them. But there's a story associated with this train that they got the hand signals wrong and the guy who went in to connect the trains actually got his head crushed in the buffers. We have lots of reports of people suffering headaches in this area and seeing the figure of a man.'

I must admit that it wasn't a headache I felt, but the hairs on my neck were prickling as I really did feel like I was being watched from the compartment above the buffers that had killed a man.

I mentioned that the enormous black carriage next to Queen Victoria's was also making me feel odd. Tony said that there were stories of a woman wearing a white dress, who had been seen walking alongside this carriage.

He described a time when one of his team had seen this apparition but in the dark gloom hadn't realised what he was seeing. The team member shone his torch in front of the woman, thinking that it was just another teammate without a torch and in need of guidance, but as the light struck the ground in front of her, she vanished.

Looking back on our night at the NRM in hindsight I still don't know what made me feel so differently in the places where apparitions had been seen. I can't rule out that there were some other factors which made me feel different, such as the positioning of air conditioning vents, uneven floor surfaces or maybe just overhearing something earlier in the night which subliminally was stored in my brain. What I do know is that I'm usually a very calm person and I am able to notice when my emotions change, especially when that change is toward 'fear' like I felt so vividly on the bridge. I don't have issues with heights – I am learning to fly and fear of heights would be a problem for that! I don't have balance issues; I am an instructor of Taekwondo, so my balance is pretty good. And I usually don't like to draw attention to myself unnecessarily, especially to a group of experienced ghost hunters who might consider me a liability to their investigations.

Yet, every time I felt strange there had been prior reports of 'something' happening there. So perhaps people do leave behind some energy or a spirit when they pass on.

Duane had been to the TPO to collect the locked-off camera as Rich had been recollecting his experience at the Royal Carriages to me, and upon quickly scanning through the video footage it had appeared to capture no movement whatsoever.

It was after 4.00 a.m. when we thanked the P.A.R(t) guys, who are a brilliant group of lads, and said our goodbyes. We grabbed our belongings and headed outside

into the staff car park which was covered in a thick frost as it was bloody freezing! Thankfully the walk back to Bar Convert was mercifully short and would only take us five minutes. We all shared thoughts and experiences of our brilliant night at the NRM as we walked the deserted streets. The only person we saw was a young lad who'd obviously had a big night out on the drink in York and was fast asleep sat upright in a bus shelter wearing just a short-sleeved shirt. In fact in hindsight it was such a cold night that the young reveller may well have been dead, but we were so tired and so cold that at the time that thought never entered my head.

I got to bed at 4.30 a.m. and was out like a light. However, I was rudely awoken just three and a half hours later by a loud, repetitive banging sound coming from the room next to mine – John's room. I sat up with a start and it took me a few moments to get my bearings due to being absolutely exhausted and being in unfamiliar surroundings. I checked the time and it was only 8.00 a.m., there was almost two hours remaining before we'd agreed to meet. I tried to get back to sleep but the banging continued for almost ten minutes by which time I was wide awake. I went for a shower and lay on my bed looking through the photograph on my camera from the investigation which had ended only a few short hours earlier.

We'd agreed to meet downstairs at 9.50 a.m., but when I turned up John was the only other person there. We assumed the others wouldn't be too long and I took the opportunity to ask John if he was to blame for the really loud banging at 8.00 a.m. He replied, completely expressionless, 'oh yeah, that was me getting dressed'. Getting dressed? It sounded to me like he was building a shed! I was too tired to get into a discussion about it though so I simply nodded in agreement and said 'oh right'.

The grandfather clock we were stood next to chimed for 10.00 a.m. and there was still no sign of the other three. At just after five past we heard voices heading our way, and a moment or two later Rich, Tom, and a rather dishevelled Andy appeared. Before John or I could speak, Tom, being only too aware of his own reputation for having dreadful punctuality, launched a pre-emptive strike by discreetly pointing at Andy and mouthing the words 'it was his fault'. John said, 'What time do you call this?' to which Andy responded rather vitriolic 'I wasn't late, how could I be when I woke up at 9.50 a.m., which is what we agreed?' He went on to tell us that he'd not set his alarm as he decided it was better to just sleep until he woke up, and because of people rushing him about he'd not time to have a wash or brush his teeth. He seemed a bit grumpy, tired and confused, so I decided not to point out the fact that even if he'd gotten up earlier he'd not brought anything with him to have a wash or brush his teeth anyway. All he'd brought with him was a can of Diet Coke – which he'd drunk before we'd even left Newcastle – his camera, and a clean pair of underpants – which would be going back to Newcastle as clean as they were when they left, as he told us he'd not even had time to change into them.

Andy was still complaining when we got into my car for the ninety-minute drive home. We may have been leaving York for now but I echo the comments Rich made as we joined the A19: 'One investigation down and nine more to go; I can't wait!' It wouldn't be long before we'd be heading back to York for the next venue; however, unbeknown to the others, one of our number had found our night at the NRM to be such an intensely frightening experience that it would be their one and only investigation.

CHAPTER TWO

WHO YOU GONNA CALL?

Best Western Dean Court Hotel – 17/03/11

The men strode purposefully towards the entrance to the oldest living convent in England, home to the nuns of this most ethereal of cities for the last 325 years. One of the men approached the reception desk and, as the sister looked up from her paperwork, he declared loudly, 'Hello, we're the Ghostbusters'.

This may sound like a scene from one of the brilliant *Ghostbusters* movies from the 1980s; however, this was actually Tom's opening gambit to a rather confused, and slightly scared, sister upon our arrival at Bar Convent, which was to be our home once more during our time in York. Thankfully we didn't need to elaborate on Tom's grandiose introduction as another nun had overheard and knew of us coming so called for our genial host.

We were shown to our rooms in which we would be able to get some much needed rest over the next forty-eight hours. We dropped our bags off, containing our clothes and equipment for the two investigations that lay ahead, the first of which would be the Dean Court Hotel that evening. We immediately headed back outside and began the short twenty-minute walk into York city centre. John had been obsessing about a sandwich from the York Hog Roast since he and I were last in York a few days before Christmas, braving sub-zero temperatures to do a bit of last-minute Christmas shopping and check out a couple of potential locations, so it was agreed this would be our first port of call.

It was very cold and extremely windy, but at least it was dry. It was nearing 2.00 p.m. as we arrived in the city centre, we had set off from Newcastle by train almost two hours earlier, and our team was a little depleted from the five who'd come to York for our previous investigation a little over five months ago. The only members of the team to join me this time were Tom and John, as Rich and Andy hadn't made the journey with us. Rich had intended to join us, but at the eleventh hour a work trip had come up that he was unable to move. However, we knew he'd be right back alongside us for the remaining investigations in the weeks and months ahead. Andy, unfortunately, was a different situation altogether.

I'd been in Newcastle with Andy and John just before Christmas, having a few festive drinks at the Goose at the Garden, when Andy dropped an unexpected bombshell. He told us that as much as he'd enjoyed spending time with the lads on the trip to the NRM, he didn't feel comfortable during the investigation. He said that he was genuinely freaked out when we were speaking out in darkened rooms asking for things to happen and for unseen hands to touch him. It really hit home to him how real the paranormal could be, and he was scared. These weren't things that he wanted to do

again, so he wouldn't be continuing on the York adventure. I tried to talk him around but he'd been considering it since the investigation and his mind was made up.

Back in York, by 3.00 p.m. it was becoming a struggle to walk into the unforgiving gale-force winds which were raging through the ancient cobbled streets and Snickelways, so we agreed to find somewhere we could sit down and begin to map out our plans for our investigation at the Dean Court Hotel. We headed to the pub that we'd adopted as our 'local' on our many visits to York, The Cross Keys on Goodramgate.

The pub had undergone a snazzy revamp since I was last in with John at Christmastime. We picked a table, got some drinks, and in a quiet corner of a fairly empty pub I told the guys all about York's most haunted hotel – The Dean Court Hotel.

The building which is today the Dean Court Hotel was originally built between 1864 and 1865 as three separate dwellings for Dean Duncombe, the then Dean of York Minster, to house the Clergy.

At the end of the First World War the middle building was bought and turned into a hotel by the Thwaite family. As the decades passed, the hotel's ownership changed regularly and by the 1960s had expanded to take in all three original buildings. The name changed to the Dean Court, although the exact year in which this name change took place is unknown.

In 1978, the adjoining property, a medieval cottage with a mock-Georgian façade bolted on, was purchased by the Washington family who had bought the Dean Court in 1969. The cottage had previously been used as a small guest house in the 1930s named Vollans. In 1986 the Dean Court and cottage changed hands once more, and the cottage was integrated into the hotel. Between 2004 and 2007 the Dean Court Hotel was completely restyled into the award-winning, four-star, thirty-seven-room hotel that it is today.

As well as being known for being one of York's top hotels, the Dean Court Hotel has a reputation of being one of York's most haunted buildings, with one website claiming it to be home to no less than thirteen separate spirits.

A phantom Roman soldier has been seen throughout the hotel, and his association to the building is a puzzling one. The end of the Roman rule in Britain was at the beginning

The Best Western Dean Court Hotel.

of the fifth century, with the last troops leaving in 407, over 1,400 years before the Dean Court was built. It appears he must have a connection to the area as during the Roman occupation of York the hotel was close to the site of a Roman army headquarters that lay to the east. He has been seen in most areas of the hotel with visitors even seeing him walk through their rooms. In 2001, three young ladies sharing a room were getting ready for a night out; they were doing their hair and putting their make-up on. All three then clearly saw in the mirror a man wearing a Roman helmet walk behind them, stop and then turn to face them. Too scared to even speak, they turned around but could see nothing. When they looked back in the mirror, to their horror they could still see him standing perfectly still. He was there for a couple of minutes before fading away.

The most commonly reported ghost is that of a Victorian maid who is seen in the basement by staff. The maid was in the employ of the Vollans Hotel, which is now part of the building. It is believed that her quarters were in the area which now makes up the kitchen and part of the McCloud Suite.

There are daily 'invisible' phenomena, with visitors reporting activity such as waking suddenly and feeling freezing cold even on the warmest summer nights. They feel something in the room just isn't right and are convinced they can make out dark 'man-shaped' shadows moving around their room, but when they pluck up the courage to turn on the light the room is empty and the temperature quickly returns to normal. Other witnesses have experienced being pushed down into their beds, as if a great weight is pushing down onto their chest, making it difficult to breath and impossible to move or speak.

This really whetted the appetites of all three of us and we chatted excitedly about what the Dean Court might have in store for us, and how best to approach the investigation.

By the time we left the Cross Keys at around 6.00 p.m. it was dark outside and the streets were almost deserted. The weather hadn't improved, it was worse; the wind was even stronger, and the temperature had dropped considerably. We walked out of the city centre and headed for another pub where we'd already decided we would have our evening meal, the Punchbowl at Micklegate Bar, part of the Wetherspoon's chain famed for their vast, yet competitively priced, assortment of beverages, and it was conveniently located just across the road from Bar Convent. It was Curry Club night at the Punchbowl too, which was something that excited John enormously.

The Punchbowl is known as being one of York's many haunted public houses, believed to be home to a former landlord who burnt to death in a fire that broke out in the building, and he is seen in one of the bedrooms and the cellar. The shade of a woman has been reported in the bar area, said to be that of a young lady in her twenties who died of a broken heart.

When we entered the Punchbowl we discovered that John wasn't the only person excited by the prospect of Curry Club, the place was bursting at the seams with diners gorging themselves on chicken korma and lamb rogan josh, and there wasn't an empty table in sight. Fortunately, we spotted some people getting up to leave and quickly took their place at a small table towards the back of the pub.

A little after 8.00 p.m., fed and watered, we left the warmth of the Punchbowl and headed out into the cold night's air, crossed the road and entered Bar Convent. We each went off to our own rooms, agreeing to meet up again at 9.30 p.m. This would give us almost an hour and a half to relax and prepare for the evening ahead.

Just before 9.30 p.m. I got changed into the clothes I'd packed for this evening: combat trousers, t-shirt, jumper and a hoodie, picked up my bag and went to meet the lads. Tom was also sporting the hoodie look, while John was in his trademark massive black coat with a woolly hat perched on top of his head.

We quietly made our way through the snaking corridors and winding staircases that make up Bar Convent. When we'd been shown to our rooms earlier in the day we'd been made aware of two different routes to get up to the tower in which we were staying; one involved going outside crossing through the gardens and then back into a different part of the building. This was the route we decided to take, but when we went out into the gardens it quickly became apparent we'd opted for the wrong route; the door back into the other area of Bar Convent was locked. I turned to tell the others just in time to see Tom slam shut the door we'd came out of. That door was now locked too and all the lights were off on the ground floor of the building. We were stuck and we couldn't have looked any more suspicious; three men all dressed in black, waving torches around in the back garden of a building full of nuns. I checked my watch; the illuminated screen displayed 21.41. We were expected at the Dean Court Hotel in less than twenty minutes and I considered calling them to let them know that because of the bizarre situation we found ourselves in we might not actually make it, not only that but we might have to spend the night out here. As the minutes ticked by we were all growing increasingly concerned, but just then a glimmer of hope; a light came on through one of the ground floor windows towards the centre of the building and we saw a figure walk past. As Tom and John knocked on the window, unsuccessfully attempting to attract someone's attention, I pressed my face to the window of the door we'd came out of, peering into the darkness looking for any sign of movement. Suddenly the door opened and I came face to face with a man who looked absolutely terrified as he'd clearly not expected anyone to be there, especially not a dark figure wearing a hood! His eyes grew even wider with fear and concern as I was suddenly flanked either side by the shadowy figures of John and Tom. Neither of us had spoken for what seemed like an eternity before he blurted out 'Who are you and what are you doing here?' We tried to calmly explain the situation but he didn't seem convinced by our story, which probably did sound a little far-fetched despite it being the truth. All the same, he let us in. We thanked him and headed out onto Blossom Street and, albeit a little later than planned, we were finally on our way to the Dean Court Hotel.

It was just before 10.15 p.m. when we arrived at the luxurious, award-winning Dean Court Hotel. I elected myself as spokesperson and approached the front desk. When the receptionist politely enquired as to how she could help I told her that we were here to look for ghosts. She looked a little confused, but a man appeared out of a side door having overheard our exchange. He was Scott Burton, the deputy manager, and he'd been expecting us.

We all introduced ourselves and Scott kindly took us around the hotel showing us the areas that we'd have access to: the basement area including the McCloud Suite, the third floor, also known as the '30s' due to the door numbers, and the sixth floor, or '60s'. However, some of the rooms on this floor were occupied so if we went to that area we would have to ensure we didn't disturb the guests.

Scott told us of some of the experiences that he'd been made aware of by members of staff and visitors. Earlier that year a female member of staff was descending the staircase

Above left: The staircase leading down to the basement.

Above right: Rob in Room 34. (Photograph by Tom Kirkup)

leading to the basement when she heard someone clearly whisper in her ear, she quickly turned to see who was there but she was alone. She tentatively continued her descent when she heard the distinctive footsteps of someone coming down the stairs behind her; this came as a relief to her as she'd been a bit shaken by the whispering a few moments earlier. She reached the bottom of the staircase and turned around to see who it was, but as she turned the footsteps stopped immediately and to her abject horror there was no one there. She was panicking now and her heart was pounding so hard it was almost bursting out of her chest. She didn't want to be alone down there a second longer, but just as she was about to go back up the stairs she felt hands grab her firmly around the waist. At first she was too frozen with fear to look back, but she realised it might have been one of her colleagues, so slowly turned her head to see. However, she was still alone. She screamed and ran up the stairs as quickly as she could.

The most recent inexplicable occurrence had happened just two weeks prior, and made front page news in the local newspapers. Marc Richards, a guest from Manchester, was staying in Room 25 with his wife when we was awoken at 2.50 a.m. and felt invisible hands grab his foot and pull him down the bed. He told reporters he was pulled with such force that he actually moved down the bed.

The *York Post* also spoke to a representative of the hotel who concluded the interview by adding 'Another paranormal group is visiting the Dean Court in a few weeks to spend an all-night vigil seeking things that go bump in the night'. That group was us and the all-night vigil was about to begin. I couldn't wait. I was bubbling over with nervous excitement to find out what lay in store for us.

Before wishing us luck and leaving us to our investigation, Scott handed us the key cards to Rooms 34 and 37, two rooms notorious for their paranormal activity, with temperatures dropping considerably in seconds, and things being moved around by unseen hands. We asked about Room 25, the room in which the terrified guest was almost pulled out of bed; however, an unwitting visitor was already booked into the room.

We'd agreed earlier in the day that since our team numbered so few, the best way to investigate the Dean Court Hotel would be to systematically spend time in each area, staying together as one group so any experiences could be corroborated. John suggested we begin in the 30s and make the most of the two bedrooms that Scott had given us access to.

As we entered Room 34 we all commented on how large and well-appointed the double room was. John and I sat down in two comfy armchairs and Tom sat on the end of the bed. We decided to use this room as our hub for the evening, and as we unpacked and organised our equipment Tom said that that the hotel didn't have the look or feel of your typical haunted house. He was right, but looks can be deceiving as, no sooner had Tom finished speaking, the silence was broken by a loud knock which came from the empty bathroom. I looked at Tom and he looked back at me; neither of us needed to say a thing, we'd all heard it. The investigation had barely begun and already it appeared that we might well be in for one hell of a night.

I left Tom and John in Room 34 and I crossed the landing to Room 37. I set up a trigger object on a bedside table, a crucifix, which I placed onto a piece of paper and drew around it, so if it was moved it would be immediately apparent. I also positioned a digital voice recorder next to the paper and pressed record. I left the room, checking the door was locked behind me, and rejoined the others in Room 34.

While I'd been out of the room, Tom had been taking some photographs. He took a photograph of John sitting in a chair, and there were orbs in the photograph, he took another immediately afterwards from exactly the same position and there was not an orb in sight.

We decided to turn the lights off and attempt to communicate with whoever, or whatever, might be with us in Room 34 in the form of EVP using a second voice recorder. Tom pressed record and introduced the recording by confirming the time 10.38 p.m., describing the room and explaining that there might be traffic noises from the road which ran beneath the bedroom window. As Tom spoke John took a pair of stainless steel dowsing rods from his bag which he held loosely in each hand. Tom went on to express our utmost respect and our reasons for being at the Dean Court Hotel and then asked a range of questions, leaving several seconds between each one in hope of a response.

At 10.49 p.m., eleven minutes into the session, we all jumped in response to a loud bang which came from the bathroom. It appeared to come in direct response to Tom's request 'Bang on a door or a table if you wish us to leave'. Tom asked for another knock if the presence wanted us to leave the room; however, this was greeted with silence. Tom brought the recording to a close at 11.00 p.m. with the bang from the bathroom being the only direct response to any of our questions; we'd heard nothing, seen nothing, and John's dowsing rods hadn't moved.

We reflected on the last twenty minutes, with Tom passing comment that the room felt 'flat', as if we were on our own, and there wasn't anything otherworldly present,

'Can you give us a sign?' Tom attempts to contact the ghosts of Room 34.

and if there was it certainly didn't want to let us know. As John and Tom continued to talk, I clicked on my torch and went to investigate the bathroom in an attempt to locate what could have made the loud bang we'd heard during the EVP session. I opened the door and entered the darkened bathroom, the atmosphere felt somehow different to the bedroom, which had felt so inviting and comfortable. I felt uneasy and as if I wasn't alone. I searched for something that could have perhaps fallen off the shelf and made the noise, but came up with no explanation for the sound. When I returned to the bedroom with the others I felt relieved to be out of the bathroom.

We began to listen back to the recording just after 11.10 p.m. and just as Tom pressed play there was a shuffling noise in the corridor outside which moved slowly past the room door. We rushed to the door and opened it, but as we opened the door the noise stopped and the corridor was completely deserted.

As we listened back to the recording we were amazed to hear that we'd captured some staggering responses to several of Tom's questions. All of which were completely unheard by any of us during the session, and with the crystal-clear sound quality of the Olympus LS-5 digital voice recorder, the sounds were unmistakable:

'If you feel threatened by us and would like us to leave please give us a sound?' This was followed by a screech into the recorder.

'If you like us being here please give us a sign?' This was followed by a rustling sound, then a knock, and then a definite man's sigh. It sounded close to the recorder which was positioned well away from the three of us.

'Do you know what year it is?' This was immediately followed by a loud knock.

'Is there a year which is significant to you?' This was closely followed by a rustle, then a knock, then a few seconds of silence and another knock, and then a very loud, very long, man's sigh.

'Is there any way we can help you?' I was chilled to my bones as I heard the result to this question, and looked at the others who looked back at me in disbelief. There was

clearly a man mumbling, as if he were trying to tell us something but not able to get the words out. This lasted for eleven seconds. This was Tom's last question before he said thank you and closed the session.

As the playback came to an end, we were all in shock at the inexplicable and unexpected sounds we had just heard. It appeared that there may well have been at least one spirit in the room with us attempting to communicate so we pressed record on the voice recorder and began to ask some more questions, with immediate results. Tom's first request was 'Can you make the rods in John's hand move?' I looked at John and the rod in his right hand slowly swung outwards. The next question was 'Can you make a noise?' at which point there was a knocking sound which we all agreed had appeared to come from the table that the voice recorder was positioned upon. This was followed by several questions to which we heard no response, until Tom said 'Is someone keeping you here?' and there was a loud bang which sounded like it was just outside of the room.

At close to midnight we ended the recording, and with huge expectations we listened back to it immediately. As we listened back we clearly heard the sounds that we had heard during the session, but I was a little disappointed that it appeared there were no additional sounds that we hadn't heard at the time. This was until we reached the very last question on the recording; the only question that I had asked, and the truly astonishing, yet terrifying, response. 'We are giving you an opportunity to let us know if there is a life after death and find out more about your life. We're very curious so please let us know if you exist somehow. Show yourself? Touch one of us?' On the recording a female voice answers, very faint so we couldn't make out her actual words, but very clear and definite.

As we were coming to terms with another astounding result Tom said that he could hear a heavy breathing in the room while listening back to both recordings. John answered that he could hear it too but thought it was Rob. I didn't hear the breathing, but I know it wasn't me.

By now it was nearing 12.30 a.m., so we reluctantly agreed that although Room 34 had been a truly amazing, unforgettable experience, we should move on and investigate the other areas of the hotel.

We relocated to Room 37, a twin room of a similar size to the room we'd just left. I checked on the trigger object and was slightly deflated to see that it hadn't moved. I then realised the voice recorder was no longer recording, it was turned off. I tried to turn it back on but the batteries were dead. I'd replaced the batteries back in Bar Convent only a few hours ago before we left for the hotel and the battery life is usually in excess of eight hours. It may have been something paranormal which had caused the batteries to drain; however, I suspect it's much more likely to be as a result of me buying twenty AAA batteries for a quid earlier in the day.

We turned off our head torches and as I sat down in an armchair I realised the curtains behind me were ever so slightly open which was letting in a sliver of light from a streetlight outside, and casting my shadow across the room. As I stood up to close the curtains I took the opportunity to look outside and I was greeted with the most awesome view of York Minster bathed in light against the clear night's sky.

Given the success we'd had in Room 34 I proposed we try asking out for responses to our questions, with the recorder hopefully capturing EVP. As John began to answer he was interrupted by a loud groan which came from the bathroom. I was so convinced

Above left: John and Tom in Room 37.

Above right: : Tom investigates the basement.

The McCloud Suite.

that someone was in the room with us that my immediate reaction was to stand up in case they came out to confront us. John bravely went to see what could have made the noise. The bathroom was empty. He had a quick look around the bathroom but found nothing unusual. John tried to rationalise what we had heard: perhaps it was just the room settling?

Tom began to ask out for any spirits with us to make themselves known, and went on to ask a number of questions and requests. However, during the session we had no response. We listened back to the recording but were disappointed, and frustrated, that there was nothing paranormal during the twenty minutes of playback.

With the time fast approaching 1.15 a.m. we left Room 37 and successfully managed to navigate our way in the darkness to the lowest part of the hotel, the basement. The basement area seemed completely different now to how it had been only a few hours earlier, when there'd been an almost constant stream of staff members passing by us and there was the reassuring hubbub of people chatting over the sound of machinery. However, there was now only the three of us and it was as silent as the proverbial grave.

We clicked off our head torches and, in the inky blackness that seemed to be closing in around us, I asked out for anyone that may be with us, perhaps the spirit that grabbed the terrified member of staff earlier in the year, to let us know that we weren't alone. At that exact moment there was a very loud clanging noise from down a corridor close to where we were. This was followed by another equally loud clang. I'm not ashamed to say that it made me jump and use an expletive or two, it was that loud. John, level-headed as always, suggested that it was probably some of the machinery, in use earlier, cooling down. I continued to ask out for fifteen minutes, but despite the promising start we didn't experience anything at all. Every question was greeting by an eerie silence.

We passed through the kitchen and into the McCloud Suite at close to 1.45 a.m., a large function room dominated by a very grand, very long table surrounded by lavish chairs. We took a few photographs and then sat at the end of the table furthest from the door. I placed the voice recorder onto the table and pressed record. Rather than asking direct questions, we had a chat about how the evening had gone in the hope that anyone present with us might join in our conversation. At just after 2.00 a.m. we rounded off our investigation by attempting to make contact with the cleaner who used to work at Vollans guest house, a building which is now part of the Dean Court Hotel.

We left the McCloud Suite at 2.30 a.m. and made our way upstairs. As we climbed the stairs towards the hotel reception, I mentioned in passing to John that if the loud clanging we had heard over an hour ago was the machines cooling down, then how had we'd not heard it again since. I was feeling a little tired, but as we exited through the glass automatic doors the shock of the freezing cold wind cutting through my layers of clothing woke me up immediately. We had a thirty-minute walk ahead of us back to Bar Convent and as we walked into the biting wind we chatted excitedly about the remarkable, completely unexplainable phenomena we had encountered in York's most haunted hotel.

I got to bed a couple of minutes before 3.00 a.m., but I couldn't sleep. I was wide awake, mentally replaying the night's events over and over. I needed to try and calm my overactive mind as I had to ensure I had my wits about me for our investigation the next evening at the oldest continuously occupied house in all of the UK. I finally fell asleep at around 3.30 a.m.

CHAPTER THREE
THE FIRST TREASURER'S HOUSE

Grays Court – 18/03/11

I woke to the sound of rain on my window. The time was 9.26 a.m. and my alarm was due to go off at half past so I sleepily dragged myself out of the single bed and crossed the room to the small window overlooking the gardens at Bar Convent. The sky was grey, heavy with dark rainclouds, and it was absolutely pouring down. Great big raindrops bounced off the window as I looked down to the saturated gardens below. 'Excellent' I said to myself sarcastically, contemplating a wet day out in historic York.

After having a shower and returning to my room, no more than ten minutes later I was surprised, and glad, to see that the rain had all but stopped.

At 10.00 a.m. I crossed the landing and knocked on John's door. He answered, and looked shattered. He had every right to be tired; we hadn't got to bed until 3.00 a.m. the previous evening after returning from our investigation at Dean Court Hotel. There was no sign of Tom so I wandered along the corridor and knocked on his door. Tom didn't answer the door, but must have assumed it was me as he shouted to say he wasn't ready yet and would come to John's room within ten minutes.

By the time Tom made his belated appearance, John and I had already begun to map out our day. The rain had stopped completely now, although it was still overcast, so without further ado we put on our coats and headed outside.

We walked into the city centre, and as we walked we chatted enthusiastically about the previous evening at the Dean Court Hotel, and the investigation that lay ahead that night. John said he fancied a sandwich from the York Hog Roast situated on Stonegate, which was fine by me as I'd made arrangements for us to take in the tour of No. 35 Stonegate, the building known as 'Haunted' on account of it being York's most haunted house.

We all thoroughly enjoyed the spooky audio-led tour of the fifteenth-century building, and for me the tour served a dual-purpose: not only was I enjoying the scary stories and history with Tom, John and the other members of the public in our tour group, but I was also taking a few photograph and making a few notes as research as I had recently been deep in discussion with the owners about the possibility of us conducting an investigation at Haunted later in 2011.

We were still tired from the late night at the Dean Court, and with another late one lined up that evening, we returned to Bar Convent for a mid-afternoon siesta. My alarm woke me just before 5.00 p.m. and I felt refreshed having caught up on a couple of hours sleep. At 5.30 p.m. we popped into the pub next door, the Punchbowl, taking

all of our ghost hunting gear with us. We had a drink and an evening meal, and talked about our hopes and expectations for our investigation at Grays Court after dark. I brought the guys up to speed with the history and hauntings of the ancient house.

A Grade I listed building, believed to be the oldest continuously occupied house in the United Kingdom, the original building was built in 1080 on the command of the first Norman Archbishop of York, Thomas of Bayeux, as the residence of the Treasurers of York Minster. Grays Court was built on the site of a Roman fortress, and an excavation in 1860 found part of a store in which pottery, glass, and two fourth-century coins were discovered. The building now known as the Treasurer's House was built much later in 1419 as an extension of the original Treasurer's House. The buildings remained connected until 1720 when they were separated.

When the last of the medieval Treasurers, William Clyff, resigned in May 1547, the building was surrendered to the Crown. The King, Henry VI, gave the house to the Duke of Somerset, Edward Seymour. He was followed by a succession of private owners, each making their own additions and changes to the house. One of the many improvements is the 90-ft oak-panelled Long Gallery which was built above the lower gallery between 1588 and 1620. It is one of the few remaining original Jacobean Long Galleries in the UK.

Today the building is a stunning privately-owned boutique hotel and café, and the architecture dating from every period within its long history gives the building unrivalled character.

Then there are the ghosts. Unsurprisingly for a building of such history there are a number of ghost stories associated with Grays Court. The building has had very few paranormal investigations carried out within its ancient walls, so the stories and sightings have all come from visitors, or the people who live and/or work there. There are two actual figures seen within the building. A woman is seen walking up and down the main

Grays Court, believed to be the oldest continuously occupied house in the country.

staircase. She appears as a misty green figure, and her identity is unknown. The second phantom is that of a man wearing clothes of the Victorian era. It is believed that he may be the ghost of George Aislabie who bought the house in 1663 from Sir Thomas Fairfax. He lost his life in a duel with Jonathan Jennings in the grounds of Grays Court on 10 January 1674 for the honour of his second wife Mary Mallory. Jennings pierced Aislabie in the arm, severing an artery. Aislabie was carried inside but died of his injuries in the Long Gallery. He was buried two days later, on 12 February at York Minster. However, it appears he quickly returned to the building which was his home for eleven years, and it's even said that his ghost also walks the neighbouring Treasurer's House.

At 8.30 p.m. we were stood outside the aforementioned Treasurer's House listening to York's best-known ghost story being expertly told by a tour guide on one of York's many ghost walks.

In February 1953, an eighteen-year-old apprentice plumber called Harry Martindale was working alone in the cellars of the Treasurer's House when, just before lunchtime, he heard the sound of a trumpet nearby, not a particular tune, but just a loud note being played over and over. At first, he assumed that the sound must be coming from the road above him, or perhaps there was some kind of march or rally outside York Minster, only a stone's throw away from the Treasurer's House. However, he heard the sound repeatedly and each time it appeared to be getting closer.

Suddenly, a short Roman soldier, carrying a trumpet of sorts, appeared through the wall. Harry, understandably frightened, stepped back in shock, falling from his stepladder and scrambled into the corner of the room where he watched on in terror as the soldier crossed the room and walked through the wall opposite to where he'd entered. No sooner had the solider vanished through the wall than a large horse appeared with a soldier sat astride him, this was followed by around twenty more Roman soldiers. Each marched across the cellar and disappeared through the opposite wall. They didn't appear wispy or see-through, they appeared solid. All had dark complexions and were unkempt, dishevelled and despondent and looked at the ground as they marched. They carried short swords, spears and small circular shields and were clothed in green tunics with plumed helmets.

The most unusual feature was that the soldiers appeared to be marching on their knees, however there had recently been a small trench dug into the floor of the cellar as part of an excavation of the original Roman road which runs beneath the building. As the soldiers passed through this trench he could see their feet and they were walking along the old Roman road.

A couple of minutes after the last soldier walked through the cellar and vanished, and the mumbling he could hear throughout had ceased, he grabbed his tools and made his escape from the cellar. The first person he encountered was the curator. He saw the state of Harry and said 'by the look of you, I would say you've seen the Roman soldiers?

As the guide brought his story to an end I whispered to Tom and John 'that very same Roman road runs beneath Grays Court too'. Before they had a chance to respond we were off to the next location on the ghost walk.

The ghost walk came to an end just after 9.30 p.m. in the Shambles, and all three of us had thoroughly enjoyed it. It had set the mood perfectly for our investigation at Grays Court, which would begin just as soon as we could get there.

A short walk later we were crossing through the unlit courtyard, the full moon cast dark shadows which seemed to chase us towards the entrance. The heavy wooden door was already open, so I entered followed by the other two. There was no one there, but just before I could shout 'hello?' a lady appeared on the staircase before us. This wasn't the green lady said to haunt the building; it was our host, Penny.

We were given a tour of the building: the Sterne Room, the Bow Room, the Library, and then the oldest part of the upper floor where there is a section of the wall from the original eleventh-century building. This section of wall can be seen in a cut-out part of the current wall, through a glass panel. Finally, Penny showed us the Minster Room named for the fabulous views of York Minster from the mullioned windows.

Penny then gave us the opportunity to start in the bowels of the building, the cellar which is closed to the public. This would be the first time anyone would have investigated it. Tom and I excitedly said 'yeah, great' in unison, and John said 'cool beans!' a phrase which seemed out of character for him, and one I've never heard him say before or since. Nevertheless we were all extremely grateful for this unexpected opportunity; we would get the chance in the cellar to actually stand upon the level of the Roman road.

As we followed Penny downstairs she explained we would have to be careful as the floor was being renovated and there was a lot of clutter. She showed us around, and then wished us good luck and left us to begin our investigation.

We kicked off our ghost hunt by doing something we'd not done on either of our previous investigations – splitting up and conducting solo vigils. Tom went into a large outbuilding at the far end of the corridor, John stood in a small alcove opposite the bottom of the staircase, and I went into a small room with an enormous generator in it. This room also contained the lowest point of the entire house, for if you stood on the same level as the generator this is the original Roman level. I flicked the switch to turn off all of the lights on the floor; we were plunged into absolute darkness.

We'd agreed to spend ten minutes alone and then meet back up. The room I was in was fairly noisy as the generator was turned on. I stood on the level of the generator and turned my head torch off, there was a small window letting a little bit of light in making it possible for me to see, to my horror, the door to the room, which I had firmly closed behind me, slowly opening.

I knew it wouldn't be John or Tom as they'd have spoken their name aloud before opening the door to alert me to their presence. I stood there, open mouthed and utterly terrified, for what seemed like an age before a dark, man-shaped figure walked into the room, closing the door behind him and walking past me on the upper level of the room. I couldn't believe what I was seeing, and regained my composure sufficiently to say 'hello?'

The figure stopped and turned to look at me, and as he did so he jumped up in shock, I quickly switched on my head torch and it turned out it wasn't a ghost at all, it was the owner of the building who had no idea I was in there, and I'd almost frightened him half to death. I apologised and we laughed it off, he'd come down to

Tom prepares for his solo vigil, unaware of what was to follow.

switch the generator off, so having completed that task he wished me well and left us to our investigation.

With the generator off the room was completely silent, I could feel my heart was still pounding from my scare only moments earlier, but my heart rate quickly returned to normal. Sadly the ten minutes passed by without incident, so I switched on my head torch, illuminating the old room, and went back out into the corridor to meet the others.

John wasn't positioned where he was meant to be, which worried me briefly, but then I spotted the red LEDs from his head torch suddenly appear further along the corridor. He said that he'd experienced nothing so had quietly moved around to make the most of the space between the two rooms Tom and I were in. However, he did tell me that after only a minute or so 'some bloke' had walked down the stairs opposite where he'd been stood, and John had said 'hello?' in the darkness, absolutely terrifying him. It's no wonder the poor guy had jumped so high when I'd said the exact same thing to him in the generator room only moments later. It's certainly not what you expect in your own home.

We went along to meet up with Tom. He was stood in the open doorway waiting for us and he looked a little concerned. I asked him what was wrong, and he told us what had happened when he'd closed the door of the room and turned his torch off.

After Penny left us we began by doing a small recce of the cellar. Knowing we were limited to the time we could spend in this area, we would choose three areas to investigate, each in solitude, for a short time, with the intention of then meeting up, comparing notes, and deciding how best to proceed. When doing the recce there was one area in particular

that made me feel more uneasy that the others, and really got my heart racing; sure enough it was decided I would be left alone to investigate that area; the outbuilding – cold, dark, and currently being renovated, there was just something about the area that made me feel anxious and on edge. In truth, probably not the scariest room on the face of it, but there was something that I couldn't quite put my finger on that made me apprehensive. However, I was ready to face this challenge head-on.

We took our positions, turned off all forms of light, and waited in complete silence. As mentioned earlier the outbuilding was currently being renovated, so there were building materials and tools lying around everywhere, cluttering the area. As I made myself comfortable, I was careful not to knock anything. I scouted the area in the dark to minimise the chances of me confusing anything later with something unexplainable.

Still feeling slightly uneasy I began asking questions in my mind, trying to communicate with the 'other side' … 'Is there anyone there?', 'Give me a sign?', 'Why are you here?', 'How many are there of you?', 'Can you see me?' The questions continued … Why did I not ask these questions out loud you may ask? Well, I didn't want to make a noise which the other team members could then confuse with something unexplained, I wanted to remain in silence to enhance my ability to listen, and who is to say that any paranormal existence can't hear or read my thoughts?

Time passed slowly, then after approximately five minutes something happened that put me even more so on edge. Standing in a corner, my back to the wall, I was feeling more and more distressed and couldn't put my finger on why. I could feel myself breathing heavier and faster, and then in the blink of an eye it was as though what I could only describe as lightening flashed in front of my eyes. I was dumbstruck for a few seconds, 'Did I see that correctly?', 'Was my mind playing tricks on me?' and 'Am I safe?' I just wasn't sure what to make of it. At the time I put it down to a combination of me blinking and my mind playing tricks on me.

I just didn't want to stay in this area alone; however, I was not one to let this beat me, and at that moment I was convinced that this could be as good a chance as I may ever have to prove to myself that spirits do exist amongst us. Given that this was my goal from the outset I had to pull myself together and continue with my investigation. Time passed, and five minutes or so later I heard Rob and John coming down the corridor to meet me. Part of me felt relief, but part of me was disappointed I had nothing more conclusive to share with the team.

Back together we shared our experiences with one another. I considered whether to share my 'lightening' incident with Rob and John, as I was still trying to clear up in my head whether I had actually seen anything. However, one of the most important lessons I have learnt and would encourage of anyone else who partakes in an investigation is, if you ever think you may have seen, heard, or experienced anything, however farfetched it may sound, you should share it with the team, and in turn allow for research following the event, into whether any similar experiences have been recorded or spoken of (I have since researched this, but failed to find any similar historic experiences).

I told the team of my feeling of unease and recommended we investigate the area further together. Would this area throw up any further strange happenings … ?

On hearing of Tom's bizarre experience John and I were game to follow up on his suggestion of investigating the unremarkable outbuilding further to see what it had to offer. We entered the room one by one, and John commented on the slight draught that seemed to be coming from somewhere, but upon investigating further we couldn't quite pinpoint where.

We spread ourselves out around the room as best we could and Tom closed the door. I turned the lights off at the switch and we asked for a sign that we were not alone. The heavy door, which Tom had just closed, opened slowly by its own volition and then slammed shut, giving us all a major fright, and causing John to swear loudly.

We rushed out of the room to see if anyone was outside who could have opened and closed the door, but there was no one around. I was last to leave and noticed that the floorboards just outside of the room were a little creaky and if it had been a person who'd opened and closed the door we'd have heard them approaching. Just as I said this a light went on at the other end of the corridor, and without saying a word John went to investigate. He returned shortly and said he'd bumped into a woman, who he'd terrified, who'd come down to get some wine. He'd asked her if she'd been down the corridor to the room we were in, but she explained she'd only just come downstairs.

It had been a good five minutes since we'd left the room and I pointed out to the others that the door, which was closed, hadn't moved in all the time we'd been stood outside, so it seemed unlikely it could have been caused by the slight draught we'd felt, or it would be constantly opening and closing. It appeared to come in direct response to our challenge for proof that we were not alone.

We went back into the room, and somehow I'd been elected to stand next to what John described as the 'spooky door'. I spoke aloud, asking the very same question as earlier 'Can you give us a sign that we are not alone?' We waited, the air was thick was anticipation. There was a knock from somewhere in the room. 'Can you move the door like you did earlier?' The door opened slightly. The others had seen it too. None of us could believe what we were seeing, but we needed more, we needed to know beyond all doubt that this was definitely not caused by something natural. I had been careful not to move a muscle in case a floorboard could somehow move and make the door move, there was still that light constant breeze, but I was convinced that the door was moving too infrequently for that to be the cause.

'Can you do something else for us, could you make a noise?' there was no response. 'Could you move the door again?' The spirit(s) in that room didn't need to be asked twice, the door swung open much further, wide enough that I could have walked out of the room, and then stopped completely still once more. We'd only been given an hour in the cellar and our time was running out, we only had five minutes left. I asked for the door to move again, but this time it didn't move, and nothing further happened during our remaining time. However, we'd had a blistering start to our investigation with a door actually opening and closing on request.

We gathered our belongings and relocated to the Minster Room, stopping just before we reached it to take in the cut-away view of the wall dating right back to the original building, almost 1,000 years ago.

The Minster Room, also known as the Fairfax Room, is a grand sixteenth-century panelled room dominated by a splendid oak table with eight seats. I was awestruck once more by the view of York Minster, which no matter how many times I visit York never fails to impress.

We spread ourselves around the large table, and John led the session this time, stating our intent and asking for co-operation. I pressed record on my Olympus digital recorder and placed it into the centre of the table. He asked a series of questions, and made a number of requests for activity. I stared up at the huge chandelier hanging down from the centre of the ceiling and listened intently. Sadly, we heard nothing. We listened back to the recording as there was the hope that EVP may have been captured, but that threw up nothing out of the ordinary either.

As a change of approach I suggested that John attempt to communicate using the dowsing rods he had brought with him. Dowsing rods have been used for centuries with great success in finding water or ore, and these days they are a fairly common, and inexpensive, piece of kit that most paranormal investigators will have in their arsenal. John loosely held the two brass rods, one in each hand, in front of him and stood up. He requested that the rods should move outwards for a negative answer, and should move inwards, crossing, if the answer is positive. He asked if there were any spirits with us; the rods didn't move. He asked if the spirits wanted us to leave, again the rods stayed still. We'd not quite given up on the dowsing rods yet though, and John instead asked if any spirits with us could move the rods to point to where they currently were in the room – again, nothing.

'Can you point to where Rob currently is?' This time the rods initially moved ever so slightly, and then both swung around to point directly at the seat I was sat in. This was interesting and we discussed from a sceptical view that subconscious micro-movements in John's hands could have caused the rods to move, and since he knew who I was that could be why the rods appeared to answer correctly. I proposed an experiment,

John asks for the ghosts of the Minster Room to make themselves known.

John utilises his
dowsing rods
in an attempt
to gather more
information
about the
spirits of the
ancient house.

knowing that John had a compass in his bags, I asked him to ask for the rods to point due north. He did this and the rods moved slightly again, before swinging around and both pointing in a definite direction. John stood still while Tom got the compass to compare where they were pointing and where north actually is. The rods were pointing almost precisely south.

This had been an interesting, but inconclusive experiment, so John put the rods away and took out a crystal pendulum, another common piece of equipment to see at a paranormal investigation. He held it by a length of chain over the table and swung it back and forth explaining that this would be the sign for 'yes', and then side to side, adding that this would mean 'no', a circular motion would mean 'unsure'. He held the chain still and said 'Are there any spirits here with us?' it slowly began to move and then very definitely swung from side to side, the sign for no. This took us a little bit of time to get our head around, I suggested perhaps we'd encountered a playful spirit who found the opportunity to answer no to that question too hard to resist, and perhaps who was also responsible for pointing the dowsing rods precisely south when we'd asked for north. Of course this was pure speculation, a quick time check showed it was 11.40 p.m. and with no further time to dwell on it, we moved on to the next room.

We entered the Library, there were, as you'd expect, lots and lots of books, a well-stocked bar with a chess board upon it and a guitar propped up against it. There was a light coming from behind the bar so I went to find out what it was; it was a fridge beneath the bar, which was also making a constant humming sound. We sat at a small table, and I suggested we try a séance with a glass from the bar, Tom and John were both in agreement it was a good idea so we began with John leading the questioning. Unfortunately, there was no movement from the glass whatsoever.

I put the glass back and pressed record on my voice recorder. We were hoping to capture EVP and Tom led the session. When he initially asked for an indication that

The Library.

there was someone else there with us, I felt an icy cold breeze circling my head; John commented that he could feel this too. We were both sat in a bay window which may have been a rational explanation. However, the breeze stopped as quickly as it had begun and we didn't feel it at all after that.

The remainder of the session passed by uneventfully, and at just after midnight we relocated to the Sterne Room, named after the man who built the room, Jacques Sterne. It is a fine Georgian dining room.

Tom and I took a seat and John said he was going to investigate the Long Gallery alone. It was 12.20 p.m., and he said he'd be back before 12.30 p.m. I suggested to Tom that we space ourselves out around the room and take the ten minutes to just sit silently and see if anything happened. I picked a seat with a great view out of the window over the cobbled courtyard we'd crossed when we'd entered the house. I closed my eyes and listened, straining to hear anything at all, anything that would give us a starting point when John returned. However, the first sound I heard during those ten minutes was the heavy footsteps of John approaching. He had his red LED head torch on, and the light pierced the darkness as my eyes adjusted after being closed for the majority of the last ten minutes.

'Anything happen?' I asked. John took a moment to consider his response and then said 'yeah, maybe, I felt like I was being followed as I walked along the corridor, but I couldn't see or hear anything, it was just an odd sensation.'

In the Sterne Room we ran an EVP session, placing our recorders around us. John led the session, asking a series of questions. He then stood up and asked a spirit to appear with him on a photograph, he repeated his request over and over as I took a series of photographs, even moving a chair next to him for the spirit to sit at. I took forty-four photographs in total and unfortunately none of them captured anything unusual. We also listened back to the recording, which lasted eleven minutes, but sadly this too was devoid of anything paranormal.

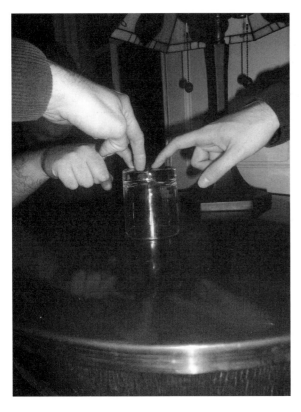

Left: The team conduct a séance. (Photograph by Tom Kirkup)

Below: Tom walks the Long Gallery in the early hours.

With the time nudging 1.00 a.m. we went to the final room we would investigate, the Bow Room, another elegant dining room open to the public all day long. It has many large tables, and there are two doors which lead into the room. The three of us sat around a table, and before we'd even started our session there was a loud creaking sound, which seemed to come from the table we were sat at. I'd pressed record on the voice recorders before this happened and it's clearly captured. John suggested that perhaps one of us had knocked the table which could have caused it to creak, but when we tried to recreate this we failed to do so. I led the session, encouraged by the strange sound from the table. 'Can you touch one of us?' 'We have recording devices on the table that may be able to hear your voice even if we are unable to. Can you speak into these devices for us?'

We heard nothing unusual, so listened back to the recording which, disappointingly, had picked up nothing either. With the time now at 1.40 a.m. we bid farewell to Grays Court.

It was freezing cold as we walked back to Bar Convent, but we'd all planned ahead and had additional layers in our bags to combat the cold early morning air. We had a walk of around twenty minutes ahead of us, and we discussed our thoughts of our night at Grays Court. We were in unanimous agreement that despite prolonged periods of inactivity it had been a huge success; with the activity in the cellar a definite highlight for us all. Indeed, Tom's experience in that cluttered outbuilding had been so convincing that it had made him completely reconsider his fairly staunch sceptical stance when it came to the paranormal.

This photograph, sent to me by Grays Court in the weeks following our investigation, appears to have amazingly captured the figure of a ghostly lady at the far end of the corridor. (Photograph reproduced by kind permission of Grays Court)

CHAPTER FOUR
THE LONG JOURNEY TO THE GALLOWS

York Tyburn – 13/05/11

Friday the 13th is a day traditionally considered to be unlucky and of potential ill fortune. Some people actually fear Friday 13th so much that on this most dreaded day they won't leave their house, this phobia is named 'friggatriskaidekaphobia', with 'Frigga' being the Norse goddess for whom Friday is named, and 'triskaidekaphobia' the fear of the number thirteen. Let's hope that it wouldn't be unlucky for us, as on Friday 13 May we were daring to once more travel to York, as across the next forty-eight hours we'd be investigating two of York's most fascinating outdoor venues.

Due to the outdoor nature of our investigation we were hopeful that the weather wouldn't be an issue, but as we drove down the A1 the weather was changeable between overcast, heavy rain, and the occasional bout of sunshine. Despite this nagging concern we were in high spirits, and even though we had all had a long day at work, the conversation was flowing and bounced from subject to subject, including a lengthy debate about what our ghost hunting team name should be, a subject we've discussed at length for the best part of a year without ever really getting any closer to picking a name. As always the conversation eventually found its way to the subject of ghosts. Tonight's venue has a dark, gruesome history, and the site will forever be linked intrinsically with death and suffering. Tonight we'd be heading to York Tyburn.

On 31 March 1379, a private soldier, Edward Hewison, was taken from a small cell at York Castle and put into the back of a horse-drawn cart. After passing through the imposing castle gateway he could see that crowds had lined the route the cart would take, men, women and children local to York cheering as the cart passed. But Edward Hewison was no hero; he was a convicted rapist and he sat atop a wooden box trembling with fear as he knew that within the hour he'd be dead. The wooden box he sat upon was his own coffin, and he would have the dubious honour of being the first man to lose his life at York Tyburn, the first official gallows in the city of York, erected at Knavesmire. It quickly earned the nickname of the 'three-legged mare' as it was built as a wooden triangle standing on three wooden pillars.

It was a long journey to the gallows and the crowd had reached fever pitch by the time Hewson arrived at York Tyburn. Silence fell as the condemned man took his final breaths and the baying crowd cheered and whooped in delight as he dangled by his neck, thrashing and fighting in vain until, less than three minutes later, he was dead.

For over 400 years York Tyburn claimed many hundreds of lives including the most famous highwayman of all time, Dick Turpin. Richard 'Dick' Turpin had been an

apprentice butcher before turning to a life of crime with the infamous Essex Gang (also known as the Gregory Gang). They robbed remote farmhouses, where they tortured and terrorised women into handing over anything of value. One particularly callous attack took place on 1 February 1735. Turpin had heard of an elderly widow named Shelley in Loughton, Essex, and they broke in threatening to murder the old lady unless she handed over her money. She refused, so they threatened to push her into the open fire, but she still wouldn't part with her life savings. However, her son was in the room watching this brutal attack on his elderly mother and shouted out, pleading with them to stop, and saying that he'd give them what they wanted.

On the 8 February 1735 the King had offered a £50 reward for the capture of the gang such was their notoriety, having carried out a vicious attack four days prior on a rich farmer by the name of Francis, they beat his wife and daughter until he surrendered the family's riches.

By the end of April many of the gang had been apprehended and executed, so Turpin turned to the crime he is best known for, he became a highwayman.
By 1737 Dick Turpin was working with 'the Gentleman Highwayman' Tom King (real name Matthew King). They forged a friendship and operated a successful partnership alongside another highwayman, Stephen Potter.

Tom King was shot at the Red Lion Pub in Whitechapel on 2 May that year, later dying from his injuries on 19 May. Some believe he was actually killed by Turpin in a tragic accident. Dick Turpin lay low in a cave at Epping Forest, but on 4 May was tracked by Thomas Morris, servant to one of the keepers of the Forest. He challenged Turpin at gunpoint, but Turpin shot him dead with his own weapon, a carbine.

Now a murderer, the Duke of Newcastle placed a £200 reward for the capture of Turpin, so he fled to York, setting up a horse dealership in the assumed name of John Palmer (Palmer was his mother's maiden name). He lived the life of a gentleman, subsidising his lifestyle with horse and cattle rustling in Lincolnshire. He was a big hit with the local gentry, but after an unsuccessful hunt he shot the cockerel of the landlord of the inn at which he was staying. When the landlord challenged him he threatened to shoot him also.

Palmer was taken into custody and enquiries were then made into how he made his money. A Justice of the Peace from Lincolnshire confirmed that he was a suspected horse thief so he was detained, later being transferred to York Castle.

Palmer was held in the dungeons of York Castle while these allegations were investigated further. This was when he made a fatal mistake; writing a letter to his brother-in-law, requesting him to 'procure an evidence from London that could give me a character that would go a great way towards my being acquitted'.

The letter was kept at the post office but his brother-in-law refused to pay the delivery charge. The letter was spotted by one of Turpin's former teachers, James Smith, who recognised the handwriting. He travelled to York Castle and identified Palmer as Turpin. Turpin was trialled and sentenced to death.

On 7 April 1739, followed by five mourners he hired the day before, Turpin was taken through York by cart to York Tyburn. Turpin was written to have 'behav'd himself with amazing assurance', and 'bow'd to the spectators as he passed'. He climbed the gallows and sat for half an hour chatting calmly to the guards and his executioner. York had no

permanent hangman, and ironically the executioner on this occasion was Thomas Hadfield, a fellow highwayman, pardoned on the condition he would act as executioner. An account in *The Gentleman's Magazine* for 7 April 1739 notes Turpin's brashness: 'Turpin behaved in an undaunted manner; as he mounted the ladder, feeling his right leg tremble, he spoke a few words to the topsman, then threw himself off, and expir'd in five minutes.'

The last execution at York Tyburn was in 1801 when Edward Hughes was executed for rape. It stood for a further eleven years before it was taken down in 1812.

There's surprisingly little written on the ghosts of York Tyburn, and there have been very few investigations carried out here. What I do know though is that the bulk of the phenomena reported by visitors to the site takes two forms: being touched and having clothes tugged by unseen hands, and ghostly voices carried on the breeze across the Knavesmire when no one else is around.

At 8.45 p.m., a little over an hour and a half after setting off from Newcastle, I parked up in Nunnery Lane car park, and we all got out to stretch our legs and gather our belongings from the boot. We crossed the road to Bar Convent, which would once again be our accommodation for the next couple of nights, and rang the bell. We were welcomed inside out of the rain, and shown to our rooms. Rich, Tom and I were on the highest floor of one building, and John was in another. We dropped our bags off and went out for some much-needed food from a nearby takeaway.

After returning and changing into suitable ghost hunting attire we headed back out into the cold – but now mercifully dry – evening at around 9.45 p.m. for the short fifteen-minute walk to York Tyburn.

When we arrived at York Tyburn, a fairly large paved area with a stone plague, we sat on the two wooden benches that look out across the Knavesmire; the large expanse of land before us, and the former site of York Tyburn. Immediately in front of us was a wooded area dense with trees and bushes on a fairly steep sloping area of earth. It was on this sloping area that the excited crowds, baying for the death of the convicted felon, would gather on the day of the execution. A popular school of thought is that the actual gallows were on the flat land at the bottom of the slope around 100 metres in front of us, rather than the spot marked by the plaque on the small paved area that we were sat at. It's amazing to think that this fairly unassuming area of land was where so many people lost their lives. When I began to think of how the prisoners must have felt as they were transported here by horse-drawn cart, sitting on top of their own coffin with the noose around their neck, I felt a chill run through me and the hair stood up on the back of my neck. There had been such a great loss of life, and such fear and suffering that if we were going to find evidence of ghosts, then this had to be the place to find them, surely. It just *had* to be.

We split into two teams to investigate the area; it was 10.10 p.m., so we agreed to meet up half an hour later at 10.40 p.m.

We stepped off the paved area into the long grass of the wooden area, and it was almost like stepping into a swamp with the group being so sodden from a day of heavy rain. I could hear grumbling behind me from the others about how their feet were soaking wet already. My trusty Adidas Sambas, however, were doing an excellent job and my feet were bone dry. The same could not be said for my legs though, as my combat trousers were soaked through and actually stuck to my legs right up to my

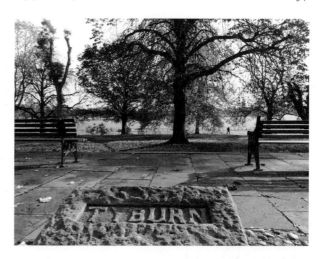

York Tyburn in the autumn.

knees. After a couple of minutes we'd reached the bottom of the slope and we were out of the long grass.

We wished each other luck and Tom and I went off to the area to the left and Rich and John headed along to the right. The Knavesmire is vast, so earlier we'd made a plan to cover a bit more of the area around where the gallows would have been to see if we could pick up on any initial activity in this peripheral area before later investigating the site of the gallows – both possible sites: the paved area with the plaque installed by York County Council said to indicate the spot of the gallows, and the possible site at the bottom of the slope believed by many historians to be a more likely area for the gallows to have been erected.

I looked out across the land but it was so dark now that we were away from the road, the street lights hidden from view by the trees and bushes, that without putting our torches on we could barely see ten metres in front of us. We tried asking for some kind of sign if there were any spirits with us, but our half an hour passed by quickly and without incident. When we were walking back to the benches to meet the others we did see a red light hovering in the air roughly 400 metres ahead of us; unfortunately, as the light moved closer and closer to us we realised it was John's head torch.

Tom and I sat on the benches and watched John and Rich approach up the soggy slope. I'd had high hopes that they would have had more luck than us, but they too had drawn a blank. We sat on the benches at the paved area, Tom and I on one bench and Rich and John on the other. Traffic was passing constantly with us being so close to a busy main road, so it was noisy, but we pressed ahead, taking some photographs in this area well lit by street lights. Rich led the session attempting to make contact with the spirits who lost their life dangling with a noose around their neck and have remained here ever since.

More than half an hour passed, and try as we might we couldn't stir up any responses to our requests for knocks, voices, touch or affect one or more of us, or actually appear to us.

At 11.30 p.m. we carefully negotiated the wet, swampy wooden slope and when we reached the bottom we stood silently. I heard a rustle in the bushes on the slope behind me but we all dismissed it as being some kind of animal.

Tom looks out across the Knavesmire.

The guys investigate the paved area at York Tyburn.

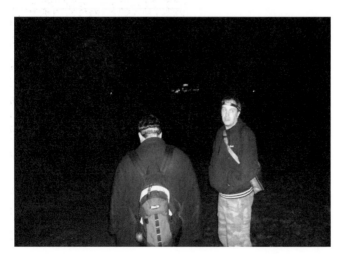

John and Rob at the site of the gallows. (Photograph by Tom Kirkup)

Tom said he was drawn to an area a short distance from where we were stood with particularly long grass. Rich joined him and they moved to that area and quietly asked out for some kind of sign that we were not alone. John and I stood quietly where we'd been for the last ten to fifteen minutes, but it seemed quiet, almost too quiet.

Tom had been taking some photographs and he and Rich ran back over excitedly. Tom showed us all a photograph he'd taken which showed a white wispy mass. Rich suggested it could be Tom's breath, so Tom returned to the same spot and tried to recreate the photograph. He did manage to capture a photograph which bore some similarity, by drawing a huge intake of breath and then exhaling right next to the camera as he took the image.

The four of us were now standing once more at the foot of the slope from the paved monument to York Tyburn. Rich span around in a hurry, making me jump, 'something touched my neck and my ear!' we discussed whether it may have been an insect; Rich said it didn't feel like an insect, but agreed it was possible.

Rich asked aloud for some kind of sign that there was a spirit, or spirits, with us. A few moments later I almost fell over, I didn't feel like I'd been pushed, but it was as if I was suddenly off-balance.

With the time nearing midnight we made a decision to call it a day. We had a long day and night ahead of us the next day, and we all felt a little deflated by our night at York Tyburn. I had been really excited by the prospect of investigating the location ever since I got the go ahead by York City Council. With such bloody, horrible history, I thought it'd be like shooting ghosts in a barrel, but it was not to be.

As we walked back towards Bar Convent, wet, cold, and disappointed, I suggested we go to the Punchbowl pub next to the convent for a nightcap, this was a popular suggestion with the others.

Little did we know at the time, but our disappointment would be short-lived. We had actually all experienced something utterly astonishing, the most compelling, concrete evidence for the existence of ghosts that any of us could ever hope for. We just didn't know it yet …

The wispy image captured by Tom. (Photograph by Tom Kirkup)

CHAPTER FIVE
THE POLLEN DODO!

Siward's Howe – 14/05/11

After a good night's sleep I awoke at around 7.30 a.m. I had arranged to meet the others at 10.00 a.m., so I tried to get back to sleep but failed. I was wide awake so lay on the single bed staring at the white ceiling above me reflecting on the disappointment that York Tyburn had been, and how I felt having brought the other lads down to York, away from their homes and their families, for such a non-event in a damp field.

I showered, got dressed and went over the photographs from the previous evening, in the vain hope that I might find something out of the ordinary which I'd missed during the actual investigation.

At 10.00 a.m. there was a knock at my door; it was Tom which was a pleasant surprise given his usual lateness. We crossed the landing and knocked on Rich's door. There was a lot of banging coming from the room but no answer for a couple of minutes. We knocked again and Rich's door opened ever so slightly and his head popped out. 'I can't find any socks, hang on'. He reappeared shortly afterwards ready to go with a huge backpack with him. 'Do you really need everything in that enormous bag?' I asked. He looked at me, then Tom, then back at me again. 'Not really' he shrugged, and placed his bag back in his room.

We went down to meet John outside the convent, or at least we tried to but we were really struggling to get through the hundreds of people crammed into the café area of the convent. It was the annual Gluten-free Food Fair and people from all over the UK had turned out to sample the gluten-free wares on offer at Bar Convent. It was a genuine struggle to negotiate our way past the crowds as they were all heading in the opposite direction to us, but eventually we managed to get outside. We were astonished to see how many people were queuing, several hundred people waiting patiently along Blossom Street. We couldn't see John anywhere and wondered if perhaps he was in the queue somewhere, as John loves food of all types, whether it contains gluten or not. We looked all over for him in his big black coat, but couldn't see him anywhere. A few minutes later he appeared and the four of us began the familiar walk into the city centre.

It was a very warm, sunny day, so warm that there was not a coat in site. We made our way to one of York's biggest visitor attractions; the Jorvik Viking Centre in Coppergate, built upon the site of an archaeological dig lasting almost six years from 1975–81, which uncovered the most amazing insight into Viking life; the houses, workshops and backyard of the Viking city of Jorvik 1,000 years ago. The Jorvik

Viking Centre took us on a fantastic voyage back into Viking times, and had such an effect on John, that in the gift shop on our way out he was toying with the idea of buying a very heavy, metal Viking axe for £60.

By now it was almost 11.30 a.m. and John was crying out for a hog roast, so we headed for the York Hog Roast shop on Stonegate. He ate his lamb sandwich as we walked to Lendal Cellars for a sit down and a drink.

Tom and Rich ordered a full English breakfast and we had a drink. I had a surprise for the guys: we'd already been to the Jorvik Viking Centre today, and we were going to continue doing 'the tourist thing', as I'd managed to secure us some free tickets to York Dungeon. This announcement was met with genuine excitement by the others. I didn't tell them at the time, but the even more exciting news was that it seemed likely we'd be seeing a lot more of the York Dungeon later in the year.

The York Dungeon was brilliant, a wonderful array of horrible characters and happenings from York's past, well-acted with great effects. We heard about Guy Fawkes, Dick Turpin, Eric Bloodaxe, the ghosts of the Golden Fleece, and many others.

There was a room in which we were told all about the plague, and Rich was selected from the group as looking like he was a plague sufferer. He had to go behind a screen where his infected innards were 'pulled out' in a shower of fake blood and gore.

After leaving the York Dungeon we chatted excitedly about our personal highlights of the tour, which had lasted nearly ninety minutes, and as we talked we headed in the direction of our regular haunt, the Cross Keys. We sat near the window of a pub we'd developed a real affinity for on our many visits to the city. We were discussing John's lack of knowledge on television, music, film, and celebrities in general, a fairly common topic. A personal highlight was Tom asking John if he knew who Bernard Matthews was; John replied with a rare confidence, 'yeah, of course, he's the fish finger man'.

A short while later Tom asked me about Eric Bloodaxe, the Viking king we'd encountered at the York Dungeon earlier. During our York Dungeon tour I'd nudged Tom and whispered quietly to him that we might encounter him again during our investigation this evening. I'd completely forgotten saying this, but with this reminder I told the others about Siward's Howe, the outdoor venue we'd be taking on in a few short hours.

Siward's Howe, also known as Heslington Hill, is part of the campus of the University of York and is famous for the imposing water tower which was built in 1955 to house one million gallons of water, making it the largest water tower in Europe. The water tower was built to serve the rapidly expanding population of York in the 1950s, and it looks more like a castle than a water tower, possibly due to the involvement of the Fine Arts Commission who had input into the design. It is now devoid of water completely, and it's believed that this has been the case since the 1980s. The machinery which was once used for pumping water has fallen into disrepair, and it's now used for storage by Yorkshire Water. There is an air of mystery surrounding the tower with rumours of three workers being killed during the construction of the massive concrete tower, and conspiracy theories surrounding its current use; it's not been used as a water tower for almost thirty years, no one is ever seen to go in or out during the day and it's surrounded by a barbed wire fence. Some people believe that the tower is not used for storage at all; it's actually used as a secret government base.

The water tower; could it be a secret government base?

The hill itself is fabled for the pagan rituals which are believed to have taken place there. Siward, the Danish Warrior, and Earl of Northumbria for who the hill is named, is believed to be buried deep beneath the hill. Another famous character from York's history believed to be buried at Siward's Howe is Eric Haraldsson, the tenth-century Viking ruler, nicknamed Eric Bloodaxe as he murdered each of his own brothers in turn.

There have been several investigations at the location across the years, with reported phenomena including footsteps heard walking around the investigators, breaking twigs and rustling leaves, and on one occasion a dark figure was seen moving in the trees before simply disappearing as quickly as it had appeared.

At 5.30 p.m. we left the pub and we savoured the glorious sunny weather as we had a leisurely stroll back to Bar Convent. We returned to our rooms at Bar Convent around 6.00 p.m. and arranged to meet at Rich's room at 9.00 p.m. All of my equipment for the investigation was already organised from the previous evening, so I sat down on my bed and the next thing I knew I was waking up. It was 8.40 p.m., so I had a shower to wake myself up and went to meet the others.

At 9.15 p.m. we jumped into my car, and ten minutes later we got our first-ever glimpse of the water tower at Siward's Howe, and it truly did look like a formidable building in the twilight. We parked in a fairly empty car park nearby, and walked back past the water tower on our way to the track which led uphill to Siward's Howe. As we walked past the water tower only a few inches from the fence keeping the public out,

I spotted some graffiti on the tower where someone must have scaled the fence which read 'think for yourself before its illegal'.

We reached the top of the hill and the thick trees and bushes meant it seemed a lot darker than it actually was. Even though we weren't too far from civilisation, we seemed quite isolated and it was really quiet, I couldn't hear the wildlife and traffic that I'd anticipated at this venue. We went for an initial walk around the area, Rich, Tom and John going into a grassy field just down the hill, and I went off alone down a dark wooded area. As I walked adjacent to the tower I heard footsteps on the crisp leaves and twigs behind me, I turned around, thinking one of the others must have decided to come and join me, but I was alone.

Five minutes later I rejoined the others, but didn't mention the footsteps I thought I'd heard. John wanted to go along the wooded area where I'd just been so we all went. I led the way, followed by Tom, then Rich, and finally John bringing up the rear. After less than a minute John commented that he thought he heard footsteps behind him.

We returned to the very top of the mound, and set up a trigger object of sorts, a leaf from a Beech tree with two twigs on top of it forming a cross. We split into two teams, Rich and Tom going in one direction, and John and I going in another, in the hope of experiencing something so we would have a good starting area in which to begin our investigation. John and I walked back along the forest track towards the road into the car park. At the bottom of the track was a subway with people coming and going all the time.

After ten minutes we returned to the top of the hill, there was no sign of Tom and Rich but after a couple of minutes they emerged from the bushes. The trigger object had moved, but it wasn't an exact test as, although to be fair the only animal we'd seen since we got here was a horse in a field, the twigs could have moved due to the wildlife at the location.

Rich spoke aloud, explaining why we were there, who we were, and asking if any spirits could grace us with a sign that they were there. At the precise moment he stopped talking, the wind, which had been almost non-existent all evening, blew so strongly that the trees around us all were banging together. Rich continued to ask questions, and the wind continued to blow. When he stopped talking, the wind died down, until all around us was total silence. We discussed whether what had just happened was something paranormal or just a coincidence. As we talked though, I noticed the trigger object, which we'd repositioned, had moved again, so now we had something else to consider. Had one of us moved it with our feet by accident? We were all in agreement that neither of these occurrences could be considered any kind of proof, so Rich said he'd speak out again to see if the wind picked up. However, before he could ask anything there was a very loud bang, and it came from inside of the empty water tower.

We split into our two teams again as I'd suggested that we discreetly walk around the three sides of the castle we could access to see if we could see if there was anyone there. John and I walked back down the track towards the subway. 'Stop, can you hear that?' I said quietly. 'Yeah, it sounds like machinery of some kind' was the response, and he confirmed what I was hearing, from inside the empty water tower I could hear whirring and beeping.

Left: The water tower hidden behind the woodland of Siward's Howe.

Below: At the top of the mound we attempt to contact the ghost of Siward, buried deep beneath our feet.

Five minutes later we were back at the summit of the mound again, and we'd not seen anything in or around the tower. We all turned our head towards the sound of talking coming from the car park below us; it was nothing paranormal, just the sound of some students, already drunk, or on their way out to get drunk. We all felt a little vulnerable and not quite so isolated anymore, they passed by though and we were free to get on with our ghost hunt.

It was after midnight now and I spoke. 'We know you're here with us, were you one of the builders killed while building the tower back in 1955?' I suddenly felt a little uneasy and, for no apparent reason, a little scared. I hadn't said anything when Rich said 'I'm shitting myself!' making me realise I wasn't the only one who'd suddenly been overcome by this inexplicable fear.

We continued with our questioning, and after a couple of minutes I felt calm again. After another forty-five minutes of inactivity we returned to my car to listen back to the recordings Rich had made through my car radio. As we walked past the water tower one last time we heard a cough come from in, or around the tower, so clearly that when I turned to the sound I expected to see someone on the other side of the barbed wire fence.

We got into my car and I turned the engine on, turning the heating up to maximum as it had been a little cold for the last couple of hours and we'd all began to feel it. Tom was in the passenger seat and passed the AUX cable from my glove compartment to Rich in the back. He connected his mobile phone which he'd been recording on and played back several recordings which he'd taken across the evening. As we listened to them I watched a couple of rabbits jumping and chasing each other around the car park, they had plenty of space to play as mine was the only car in the entire car park.

Over the recording there was a constant whisper, but we couldn't establish if it was a whisper or if it was just the wind. With it being there throughout we surmised it was most likely the latter.

After listening to all of the Siward's Howe recordings, Rich mentioned he'd recorded for a short while at York Tyburn the previous evening and hadn't listened back to it yet. He said it was just over six minutes long so we were all happy to give it a listen.

As we listened to the first couple of minutes it appeared apparent Rich had recorded the most dull conversation ever, when we had been in 'off duty' mode, as rather than us attempting to communicate with the dead, we were chatting totally carefree about some of the dullest things ever committed to MP3. After just over three minutes into the recording Tom said 'I quite like the smell of pollen', then Rich replied 'I got a big smell of that before'. As I listened I felt my heart rate quicken, and I sat upright in my seat to see if anyone else had just heard what I was almost sure I'd heard. I wasn't excited about my brother's new found love of pollen; it was what I could of sworn I'd heard immediately after he'd finished speaking. I looked at the other three in turn, and it was immediately apparent everyone else had heard it too. 'Did you hear that?' Rich said. 'Rewind it, play it again!' John responded excitedly. Rich rewound back a few seconds, and once more Tom said 'I quite like the smell of pollen', then on tape, clear as day is a third voice, the voice of what immediately sounded to me like a young girl, and my initial thought of the fairly quiet recording was that she repeated the word 'pollen' and then said a second word which is obscured by Rich's 'I got a big smell of that before'.

This was huge. We were all overwhelmed, and Rich kept rewinding the recording and playing it over and over as we listened, the excitement never waning. 'Pollen dodo?' said Rich, trying to work out what the second word could be.

At the time of the recording we'd been standing at the bottom of the slope shortly before we'd brought the York Tyburn investigation to a close. There had only been the four of us present, and we weren't close enough to the street for it to have been a member of the public. I was almost 100 per cent sure we'd captured the voice of a ghost, and it was the clearest EVP I'd ever heard.

We must have listened back to those few seconds of the recording at least fifty times in the car, and even our most ardent sceptic, Tom, couldn't offer an alternative explanation as to what it could have been.

We drove back to Bar Convent over the moon with this breakthrough, excitedly repeating the words 'Pollen dodo' over and over on the short drive home. When we parked up, we saw that the Punchbowl pub was still open so we popped in for a celebratory drink before going to bed. We were on cloud nine, and what we'd heard so clearly had completely shaken my belief system to its very core.

I didn't sleep much that night, I lay awake for hours replaying Rich's recording in my head, trying to rationalise what it could have been, but in all the time I lay there awake the only explanation I could come up with was that it was the voice of a ghost.

We met up the next morning for a fairly early 8.00 a.m. departure back to Newcastle, and all we talked about all the way home was the recording. I suggested we might want to get a sound expert to take a look, see if they could shed any additional light on it.

After dropping the others off I was back home well before midday, and the first thing I did was check my email as Rich had sent us the sound file on the drive home. I listened to it on my laptop and it was still clear as day, a girl's voice.

I contacted a freelance sound engineer named Jack Wiles through his website (www.jackwiles.co.uk) and asked if he'd be kind enough to take a look at it for us, with him being an expert in the field. He kindly agreed and responded that there was definitely an additional voice there with us, but although he wasn't able to isolate Rich's 'I got a big smell of that before' he was able to establish the second word definitely wasn't dodo, and there were actually three words in total, the second two being masked by Rich's voice.

He sent a cleaned up, louder version of Rich's original recording and when I played it back for the first time the young female voice was a lot clearer, making it a lot easier to make out the three words that the poor lost soul was saying.

'Please don't go.'

CHAPTER SIX
MANNEQUINS AND MAYHEM

York Dungeon – 16/07/11

I love the summer, with those glorious sunny days that seem to last forever, the sizzle of barbecues and the sound of lawnmowers, crowded beaches and kids kicking the ball around in the park. Ever since I'd confirmed the investigation I had lined up for tonight we'd been planning how we were going to spend our afternoon out in sun-drenched York. It'd inevitably be far too nice to spend the afternoon indoors so perhaps we'd find a shady spot in a beer garden, maybe take in an open-top bus tour, the opportunities were endless. However, now the day was finally here I looked out of the car window on my way to the train station and my view was somewhat obscured by something else synonymous with the Great British Summertime – rain. It was absolutely lashing down and had been all morning.

Tom and I arrived at Newcastle Central Station at around 11.30 a.m. and we were joined shortly afterwards by John, with Rich walking in just before midday. The Geordie Ghostbusters were reunited once more, and tonight we'd be taking on one of York's premier tourist attractions, The York Dungeon – terrifyingly good fun by day with gory mannequins at every turn and tour guides jumping out of the shadows. After dark, however, once the visitors have left and the eerie sound effects have been switched off, is it possible there's something resident to the building that's far more disturbing than anything the people who run York Dungeon could dream up?

Our train left on time from Platform 3 and we took our seats around a table. We were all disappointed by the heavy rain that was bouncing off the windows, but it was always going to be a possibility given the unpredictability of the British weather. Regardless, we were all really up for the investigation that lay ahead and we weren't going to let a bit of rain damped our spirits (if you pardon the pun).

I told the others that a few days previously I'd spoken on the phone to Krissi Neal, Marketing & Events Executive at York Dungeon, and she'd told me that she was very much looking forward to meeting us, but she wouldn't tell us of any of the activity reported in the building until after we finished our investigation to ensure that any experiences we had were our own, and in no way influenced by what we'd been told might happen in each room.

We arrived in York station at 1.30 p.m. and it had all but stopped raining. We made the short walk to Bar Convent who'd kindly offered to accommodate us once more. We'd been told to make our own way in through the main entrance and just go up to the same rooms we'd been in last time; Rich, Tom and I in the Gods and John staying

in a separate tower. The three of us were climbing the stairs when a sister we'd met a couple of times spotted us and shouted in glee for all to hear. 'It's the lads, come and see, it's our favourite lads!' A couple of sisters from nearby rooms came out to greet us. We were touched by such a warm welcome and we stopped to chat. We explained that we'd once more travelled south to York in search of ghosts and this evening we'd be seeing what York Dungeon has to offer. The sister who'd made the rallying call told us in hushed tones that she finds the paranormal fascinating, and definitely believes in ghosts. She added that as a Catholic she has to believe in spirit. She told us she once attended an exorcism and found it utterly terrifying. There was definitely something with them in that fairly ordinary looking semi-detached house. Once the exorcist had cleared the house he suggested that the children who lived there had been dabbling with dark forces that they didn't understand, and it had allowed something into their home. When asked, the children admitted they'd been 'playing' with an Ouija board.

We put our bags in our rooms and a few minutes later we were heading back through the winding corridors and staircases to meet John outside.

As we neared the city centre, huge, dark rain clouds appeared in the distance, and it wasn't long before it was raining heavily again. We were forced to dodge and weave our way past people waving umbrellas carelessly above their heads as we navigated the narrow Snickelways. John, as always, couldn't resist a hog roast sandwich, so Tom, Rich and I sheltered from the rain in a nearby doorway as we waited for him and discussed our next move. As John ate his sandwich we headed for the refuge of our adopted local, the Cross Keys.

By 4.00 p.m. the sun had made an unexpected reappearance so we took the opportunity to get back outside as Tom wanted to go and buy some 'ghost hunting sweets' to take with him to York Dungeon and Rich needed to buy a new torch. Ten minutes later it was absolutely chucking it down again. We took shelter, but when we realised it wasn't going to stop anytime soon we agreed to brave the elements and make the twenty-minute walk to a pub closer to Bar Convent.

By 7.00 p.m. we were back at Bar Convent, via the Punchbowl where we'd sat down for an evening meal. We agreed to meet at 8.10 p.m. for the short ten-minute walk to the Dungeon. I arranged my bag and read a magazine while lying on my bed, Tom and Rich went to their rooms and had a snooze.

I gave Tom a knock at 8.10 p.m., he wasn't quite ready so we chatted as he grabbed his things and as we talked Rich emerged from his room. We met John just inside the front door at 8.15 p.m. and walked to the Dungeon. I'd arranged to meet Krissi at the back door of the Dungeon at 8.30 p.m., the door used as the exit during opening hours, and as we waited we could hear the screams of a hen party coming from within. She appeared at 8.30 p.m. prompt and welcomed us inside.

The building was scary enough during the day, with gory mannequins done up to represent some of York's best-known historical figures such as Eric Bloodaxe and Dick Turpin; others are done up to depict people facing torture far beyond your worst nightmare. After dark it was going to be almost too intense, and this really hit home when Krissi showed us where we could turn all the lights on 'if things get too much'.

She took us to a room mocked up to tell the horrific grisly story of Guy Fawkes and suggested that since this room will always have a bit of light on we could use this as a

base. We left our bags in our 'base' and Krissi gave us a tour of York Dungeon, telling us we would have unrestricted access to the whole building. She asked if we would want the lights left on or off. Rich responded 'well, we have had things happen just as much with them on as off, but off please'. She explained that she'd make sure the lights were off and also that the effects such as the projections and moving mannequins were off. However, she warned us that sometimes it can take a bit of time for the air to escape from some of the effects, meaning there's a possibility that during the early part of our investigation something might jump up unexpectedly, but it probably wouldn't happen.

Krissi told us of a manager who has worked there for twenty years, and about ten years ago they saw a man on a staircase after the building had closed for the evening, puzzled as to why he was there she spoke to him but he simply vanished. The inexplicable incident generated quite a buzz in the local press.

We tiptoed quietly through the building, so as not to disturb the hen party that we were, unbeknown to them, following slowly around the Dungeon. Krissi also told us that a few years back a contractor was setting up one of the exhibits and was up his ladder when it was pulled from under him and he fell. He fled from the building and has since refused to work at the York Dungeon.

I passed comment on the mannequins, and how terrifying it could potentially be to walk around a corner in the dark to come face to face with one – especially as almost all of them are covered in blood and gore, more than not depicted as being dead, with missing limbs and/or internal organs. Krissi nodded in agreement and said 'it's the eyes', and confided in us that she says 'hello' when she passes one and she's found it to help make them appear a little less fear-provoking. During the rest of the walk around, Tom and I quietly said 'hello' to every one we passed in the hope it would work in our favour when the lights went out.

One of the many rooms we were led into had a large screen on one wall, and was made up to depict Roman gladiators with nets, tridents, sword, shields and helmets. In 2010 an extremely exciting archaeological find was made in the centre of York: Driffield Terrace, the world's only well-preserved Roman gladiator cemetery with eighty skeletons discovered a metre below ground, all having been killed in battle against their will. Some had fatal bite marks from either a bear or a big cat – perhaps a leopard or lion, brought across the Roman Empire at great expense – and many had been decapitated, as the fight would continue until just two gladiators remained, the victor holding a sword or axe to the neck of the loser, awaiting the will of the Emperor, the crowd baying for blood.

Krissi told us this was a fairly new exhibit and added that no one has ever investigated this particular room before, so if we chose to spend some time here she'd be interested to know what, if anything, we experienced.

The final room we were led to was made up to depict witch trials, complete with a stake. On the daily tours a willing, or unwilling, 'witch' is picked and tied to the stake, there's a snazzy pyrotechnic effect which shoots fire up into the air. At that point the stake revolves and when the flames subside all that remains is a charred corpse. Krissi told us that when builders were putting this set together, they experienced many odd happenings with the most common being the doors opening and closing on their own.

Krissi guided us back to the Guy Fawkes room and handed us two radios so we could contact her if we were in trouble or needed anything during the evening. The hen party's tour was drawing to an end, so she said she'd radio us in around twenty

minutes to let us know we could begin our investigation. She wished us luck and left us to prepare for our investigation.

We took this opportunity to put together a strategy for how best to tackle such a large building in the three and a half hours we would have. Rich was leading the investigation tonight, something I'd proposed to him earlier in the day. As we chatted I felt a little unnerved by the depiction of Guy Fawkes staring at me throughout, this wasn't helped by the occasional blood-curdling scream from the girls on the hen party elsewhere in the Dungeon. I hoped we wouldn't be screaming in a similar fashion later this evening.

We were confident we had a sound 'game plan' and as we waited for the nod to begin we sat back and had a drink and a chat. As we quietly talked, one of the two doors into the room swung open and a member of staff walked in. She jumped when she spotted us, obviously not expecting us to be there. She regained her composure and we all laughed about it. We began to explain who we were but she said she already knew and introduced herself as Emily. She told us that she and Krissi would be the staff on duty throughout our investigation.

She returned ten minutes later at 9.30 p.m. and told us the lights and effects were off so we were free to begin. It was time.

The first room we headed to was a mocked-up torture chamber complete with a (fake) blood-splattered chair in the centre of the room, a man being tortured on a wheel on the wall and a dungeon complete with prisoners fitted to various wicked devices of death and pain. Rich suggested that, with it being a fairly large room we stand, or sit, in a corner each. I positioned the voice recorder on the chair in the centre, pressed record and took my position in a corner. I sat down, and when I looked at the others I could see Tom, in the corner nearest the exit was also sat, while John and Rich choose to stand. I sat sitting with my back to the bars of the prison, I looked over my shoulder and through the bars I looked into the glassy eyes of the tortured mannequins, one being crushed by a wooden door with heavy rocks on it and the other in agony with his hands and feet shackled and an iron cage pinned to his stomach with a live rat in it, hot

John and Rich in the mocked-up torture chamber.

coals on top of the cage forcing the rat to take the only way out of the cage, eating its way out through the prisoner. I quietly whispered 'hello' to them both.

Rich began to explain aloud who we were and why we were there, he then began to ask for responses to his questions. He asked for a sign and I felt something lightly touch the back of my head, I turned to see what it could have been although I was fairly certain it was nothing out of the ordinary, perhaps a spider, or something hanging down brushing my head as I moved. As I turned and looked around John said 'What happened?' I didn't answer straight away as I was still looking for the source, so I got a concerned 'Rob?' from Rich who was curious as to what I was reacting to. I explained I had felt something touch my head lightly, but that it may have been nothing. We continued and Rich asked more questions. He asked 'Is there anyone here with us?' I felt something touch the top of my head again, this time I turned around quickly, startling the other guys. I was convinced something had touched me, I spotted a couple of cobwebs I'd missed earlier and touched them to check they were real and not part of the facade of the room – they were very real, so I rubbed my head to make sure nothing was on me and I seemed to be spider-free so sat back down and we continued once more.

Ten minutes or so passed uneventfully, and as Rich continued to ask questions I decided to make the most of the light in the room as there was a security light which couldn't be turned off above John's head in the corner furthest from me, and make some notes about the layout of the room and such like. I was deep in concentration trying to write legibly in the dim light of my gloomy little corner, so when Rich asked a question I didn't hear what he'd asked. All hell broke loose as I had the fright of my life. I threw my pen, notepad and camera up in the air as I scrambled to my feet in sheet terror, there's no other word for it. I badly banged my leg and elbow in the process, this brought an expletive or two from John as everyone got a fright from my sudden reaction. The reason for the pandemonium was that I had definitely felt a finger poke me hard in the back of the head just as Rich had finished speaking. It was as if someone had reached through the bars behind me and prodded me hard to get my attention. John said he'd never seen me move so fast and he and Rich came over to find out what the hell had happened, I tried to regain my composure as I told them and looked for some kind of explanation; there were torture implements on chains hanging down perhaps it was something hanging. Tom, still sat down, said he had been looking straight at me as I'd leaped up and didn't see anything touch me. I was leaning forward as I wrote so it wasn't anything hanging down. I asked what question Rich had asked prior to it all 'kicking off' and there was a sudden flicker of terrified realisation as he looked me in the eye and said 'we need to get out, now!' He'd already started leading us hurriedly out of the room when I stopped and said 'What's wrong? What did you say?' Rich turned and said 'I asked if whatever was here with us wanted us to leave to give us some kind of sign and we'd go'.

I was relieved to get out if truth be told. My heart was racing so fast I felt it was going to burst through my chest at any second. The next room depicted York's most haunted public house, The Golden Fleece, as it would have appeared in the past. The room has the unpleasant smell that a pub of yesteryear would have and there were a couple of lights on behind the bar. We were still chatting excitedly about what had happened only minutes earlier, I put the Olympus voice recorder on the bar and pressed record, then realised that I couldn't find my camera, I checked all of my pockets and I didn't

Above left: Rob, completely unaware of the mayhem what would ensue only moments after this photograph was taken. (Photograph by Tom Kirkup)

Above right: John and Rich investigate the Golden Fleece Room.

have it – it dawned on me that amid the commotion in the torture chamber I'd not picked it up before we'd been ushered out of the room by Rich. After being ordered to leave by an unwelcoming spirit only moments ago, I was going to have to return.

Tom kindly offered to come with me, but I said I'd be fine and left the guys in the Golden Fleece Room and took the short walk back along the corridor, as I walked the silence suddenly struck me, the hustle and bustle, the screams and the laughter of the Dungeon during its opening hours was replaced by an absolute, uneasy, silence. I tentatively entered the Torture Room and made my way quickly and quietly back to where I had been sat, my camera was still there. As I bent down to pick it up I was convinced 'something' was watching me from behind the bars and for the first time on any of our York investigations I was genuinely scared. I looked at the tortured mannequins and the oppression I felt from the room caused me to quicken my pace as I jogged back up the few steps and out of the room, within thirty seconds I was back with my friends and I felt safe once more.

I sat down on a long bench next to Tom and we simultaneously looked around as we heard a definite knock on a stone wall behind us. We hadn't verbalised our reason for turning around but John had also heard it. We'd only been in this room five minutes but it already appeared promising.

Rich thought aloud that perhaps some of the tankards or barrels that make up the room may have been from the Golden Fleece originally, and it's been said that spirit can attach themselves to objects and move location. Rich suggested we each take a corner again and ask out for responses due to the success we'd had in the previous room. This time all four of us sat down. No sooner had Rich began to speak that John said he felt something touch him lightly on the arm. For me this sounded far too much like the light touch I'd felt on my head in the torture room and I was becoming worried, but kept my concerns to myself.

The next fifteen minutes passed by and our requests for some kind of occurrence were met by silence, that was until around 10.20 p.m., when the nightclub above York Dungeon opened as suddenly bass-heavy dance music and footsteps could clearly be heard above us, Krissi had earlier warned us that this was likely to be the case.

We tried something different, and sat on the floor in a circle with the voice recorder in the centre. Rich then asked for anyone with us to use our energies to communicate with us. Rich said he felt a bit 'funny', but added that it could just be an after-effect of the burger he ate earlier. We had a little bit more success with this approach, and there were knocks coming from elsewhere within the room although their exact location was indistinguishable.

We agreed to move to the next room, but before we left John put a pile of coins on the bar as a trigger object for us to check later when we returned.

We followed the corridor to a section which would tell a visitor of the period in history which gave York, or Jorvik, its name – the brutal rule of the Vikings. There were two separate exhibits, one made up to show how the Christians dealt with the threat of the Vikings with a Daneskin on the wall – this was when they would capture a Viking and skin him alive, keeping the skin in one piece. This would then be nailed to the door of the church as a warning to others. The other focused around the cruel and murderous Viking King Eric Haraldsson, known as Eric Bloodaxe. The noise from the nightclub upstairs was getting louder, and seemed especially loud in this area, so we agreed to spend ten minutes in the Christian area and ten in the Viking area; however, our plea for anyone present to let us know proved fruitless, although if something did try and make a sound for us it may well have been drowned out by the bass reverberating around us from the club.

The next room was set out like a court room complete with a dock, and mannequins looking down on the accused. Upon entering the room I said 'there's something not right about this room' as I looked up at the mannequins looking down on us. 'Yeah, this is horrible,' added Rich. Once we'd turned our torches off we were in complete darkness, the only light being dim, eerie green glow from an emergency exit light above the door. Thankfully, in this room the noise from the nightclub above was barely audible, giving us the ideal opportunity to spread out around the room, set the recorders away and attempt to communicate with the unseen spirits that reside within, and even if we didn't hear anything at the time we may capture some EVP. Despite our initial reservations about the room, it proved to be a fairly uneventful fifteen minutes.

At 11.20 p.m. we left the court room and headed back to our base, the Guy Fawkes Room, to take a break and discuss what had happened so far. Rich had a brilliant suggestion of listening back to the recording in the Torture Chamber Room to see if there was anything unusual leading up to, or after, me being poked in the head. Completely inexplicably the recording from the room was no longer there, although every subsequent recording was fine.

Time was precious as we had three rooms left to investigate, so once we'd had a quick drink we were straight back in the thick of the action. We had to pass through the Torture Room on our way to our next location, and on the spur of the moment I suggested we leave my second voice recorder in the room, recording over the next hour or so as I was convinced there was something very dark and very unwelcoming lurking within. I passed the recorder to Rich to place on the chair in the centre. He

pressed record, then turned to me and said 'Have you got any more batteries? These ones are dead.' I shook my head and told him they couldn't be, I'd put two brand new batteries in that morning and then put the recorder in the 'hold' position so it couldn't accidentally be turned on in my bag on our journey to York. Not only that, but I'd then double checked the battery power of all of my equipment before we left Bar Convent before we left for the York Dungeon. All the while we were having this conversation Rich was recording on his mobile phone and on the file there is a very loud, very high-pitched whistle (or scream) immediately after Rich had told me about the batteries being dead. I listened to the recording from my primary digital voice recorder and the same noise was there too.

We arrived in the next room, the Dick Turpin Room, a spacious room, with seven long benches that visitors to the tour would sit on and watch Dick recall his life and his death on the gallows at York Tyburn on a screen at the front of the room. Rich immediately said that he didn't like the room. We each sat on a separate bench so we had plenty of space. Rich and I pressed record on our voice recorders and John began to ask for an indication that we weren't alone. The indication didn't come, but Rich continued to feel uneasy, and developed a headache, right up until we left the room at which point he felt fine almost immediately.

The Gladiator Room was next, adorned with Roman helmets, shields and weapons, and it was a completely unknown quantity as we were the first ghost hunters to grace the room after dark. We turned our torches off and the room was pitch-black. John was keen to try out a new experiment of his own design; we stood in a circle leaving a gap into which we invited 'someone' to join us. We pressed record on our voice recorders and John began by stating his name, followed by Rich, Tom, then I, then we left a gap for the fifth member of our circle to say their name in the hope the recorders would capture their voice. We then did this several more times stating facts such as the year and place of our births.

The judge and jury watch over Rich in the Court Room.

As we brought the experiment to an end Rich commented aloud that the ghosts are probably sick of the music from upstairs, the music which had by now become a lot louder. There was a loud audible groan which came from the opposite side of the room to where we were standing; no one said anything but we'd all heard it as we all turned our heads towards the sound in unison. John said it could have been someone from the club bringing the empty bottles down to a back door which was on that side of the building, and a sound that we'd heard all too often over the last hour. That may well have been what it was, but my first thoughts were that it was a definite groan which appeared to come in response to Rich's comment.

We then tried another new experiment which I'd explained to the guys earlier in the evening back at 'base' – The Human Pendulum. One person stands still, breathing deeply with their arms by their side and eyes closed. Another person will then stand in front of them and another behind. The person in front then asks for any spirits present to use this person to communicate and show us the sign for yes, and then the sign for no. This is followed by specific questions that will have yes or no answers. I volunteered to be the pendulum as not only was this a new experiment for us as a team, but it was the first time I'd used it. I closed my eyes and John began to ask questions, Tom was positioned behind me.

John said 'use Rob as method of communicating and show us the sign for yes'. Rich was sat down watching me and I tried to clear my mind of all thoughts and just 'go with it'. I felt myself moving to the right, was it down to me being a little tired after a long day, and struggling to stand completely still, or was it something else? I heard Rich say something about me moving to my left. I then heard John ask for the sign for no and I didn't move for a short while and then felt Tom touch my back, whether I'd moved back or Tom had been standing too close to me I wasn't sure but being touched broke my concentration so I suggested Tom, being the most sceptical, should attempt to be the pendulum and I take his position. John asked out again and Tom wobbled a bit but there was nothing conclusive.

Rich attempts dowsing in the Gladiator Room.

The final room, which is also the final room on the daytime tours, was the Witch Trial Room, and as we entered John said quietly, but loud enough for us all to hear, 'the Witch Trial Room at the witching hour'. I checked my watch and it was precisely midnight. As always we spread out around the room, I sat on a stool next to the stake upon which the witch would be burnt alive. John was at the opposite side of the room, stood near the entrance to a corridor leading to the gift shop at the end of the tours. Rich and Tom were sat on the floor between us. Rich asked out for anything with us to make themselves known; John heard a cough come from right behind him causing him to spin round as quickly as I've ever seen him move in the eleven years I've known him. I suggested that maybe Emily or Krissi were in the gift shop area and it might have been one of them. John shook his head and said it was *right* behind him, it wasn't down the corridor. Despite this positive start we continued to ask for signs with no response for half an hour before leaving and heading back to our base.

We had until 1.00 a.m. to conclude our investigation, so Rich put forward the idea that for the remaining half hour we should split up into two teams and spend some time in the two rooms appearing to be most active: Tom and I going to the Golden Fleece Room, and John and Rich would head to the Torture Room. We'd spend fifteen minutes there and then swap rooms.

Tom and I took our position in the Golden Fleece Room and Tom asked aloud for any spirits with us to let us know. Within only a few minutes we both clearly heard a low mumbled voice. Buoyed by this, Tom asked for the voice to answer questions. Sure enough the voice got louder and louder. However, the voice wasn't in the room with us, it was outside in the corridor and we recognised the voice as being the dulcet Geordie tones of Rich. I popped my head out of the door to see John and Rich standing along the corridor, I shouted over and asked what they were doing. Rich replied 'we were told we had to leave the room so decided to stand out here so we didn't disturb you'. I beckoned them into the room with us. As they walked towards our room I looked over

Rob and Rich listen back to a recording whilst in the Witch Trial Room. (Photograph by Tom Kirkup)

my shoulder and said to Tom 'they say they have been told to leave the Torture Room'. We both wrongly assumed that they'd meant Krissi or Emily had asked them to leave the room for some reason; however, Rich and John explained that they'd been ordered to leave by the same unwelcoming spirit that demanded we leave earlier.

Rich excitedly told us that John had been standing with his back to the prison bars in the place where I'd been touched earlier in the evening. As Rich spoke out John felt a finger firmly poke him in the back. He shouted over to Rich and told him, and Rich came and stood next to him. Rich said 'if you want us to leave give us a sign'. He felt what seemed to be two fingers prod him hard in the back. So after only two or three minutes in the room they'd been chased out and they both seemed pretty shaken, but excited at the same time. This was a major result as it appeared that the spirit seemed to understand, and respond to, our direct questions, and had twice responded to the request 'if you want us to leave, show us'. Rich also added that he didn't feel we should go back into the Torture Room that evening.

Just as Rich finished talking the air conditioning unit above our heads made an incredibly loud noise, even managing to drown out the noise from the club above. We all jumped and a few swear words were uttered in shock. Once we'd composed ourselves we all agreed that this was odd as Emily had told us the power would be off to all of the rooms. A couple of minutes later, the air conditioning unit stopped as suddenly as it had begun.

The conversation turned back to the Torture Room, and the big question was whether Tom and I should spend some time in there as it might be the last chance we ever get to investigate the York Dungeon. Tom said he'd like to go to the room, but didn't want to upset or annoy the spirit. I offered to go with him if he did want to go. So John and Rich, adamant they weren't going to return to that room, headed to base while I led Tom to the Torture Room, and into possible danger, after all we'd been told to leave this room twice already, and we could have no idea what this entity, or perhaps entities, was capable of.

We tentatively entered the room and both stood with our backs to the bars from which I was so sure I'd felt something touch me earlier. I began to speak aloud, explaining that we were back, but if we were given some kind of a sign we would leave immediately. Tom whispered to be that his heart was pounding. He didn't seem too keen to stand with his back to the bars and kept looking behind him. His uneasiness was infectious and, combined with the cool draught that I could feel coming from behind the bars, began to make me a little bit jumpy. After only five minutes we both agreed to leave 'it' alone and return to base.

Krissi contacted us on the radio at 12.50 a.m. and asked if we were starting to bring our investigation to an end. We told her we'd finished and we were in the Guy Fawkes Room packing our equipment away. A couple of minutes later Krissi and Emily came to meet us. We talked excitedly about what we'd experienced across the last few hours including the air conditioning unit turning itself on earlier. Emily confirmed our thoughts that there was no power running to it, so that shouldn't be possible. They both found it interesting that we'd had the most unbelievable happenings in the Torture Room as it's generally not associated with any kind of paranormal activity, although they did confirm that batteries draining, as with my voice recorder, had been reported,

not necessarily in the Torture Room, but in the 'Judges', or Court Room, which is next to the Torture Room. A visitor on one of the tours was trying to take photograph and the battery drained completely in seconds.

They told us, as promised, some their own personal experiences and things that have been reported by other members of staff.

Krissi told us that she's always been quite sceptical in the possible existence of ghosts, but has recently partaken in a couple of the organised paranormal investigations at the York Dungeon and admitted that it has certainly opened her eyes. She joined in a séance and there were lights appearing underneath the door which seemed to change in response to questions. Everyone in the building was inside that room, but the door was opened to check there was no one there, at which point the lights stopped completely.

She went on to tell us that on the same investigation in the Golden Fleece Room there was knocks on the barrels which seemed to come in direct response to questions asked. Emily added that she's never liked the Golden Fleece Room; it's got a 'strange feeling'.

We found the Viking area difficult to investigate due to the sound from the nightclub above, but the girls told us that a couple of mediums to visit the York Dungeon have claimed that area is the epicentre of the paranormal activity in the building because there is a portal to the other side in that area.

Krissi went on to tell us of the most commonly reported spirit, a little girl has been seen throughout the building. She is a playful spirit and visitors and staff have felt her tugging at their trousers or their sleeves.

The building was a school before it became the York Dungeon, and the ghost of a caretaker is said to wander the corridors, his footsteps have been heard as well as the jangling of his keys.

Emily told us she's often here on her own and has never felt threatened. She went on to tell us of how she was the last person out of the building one evening and was trying to set the alarm, but despite not having problems with it before it wouldn't set. She was beginning to worry as she had to catch a train to the airport but couldn't leave until the alarm was set. Then she suddenly realised that her passport was still in the top office, she rushed to the office, and then when she came back to set the alarm it worked first time. It was almost as if someone was intentionally keeping her here to help her.

The gift shop is believed to be an active area of the building; there used to be a wall of mugs and, inexplicably, they would all begin to swing. A former colleague of theirs, Kate, was in the gift shop late one afternoon when a book flew from the shelf and flew right across the room.

On another occasion, Kate was alone in the building one night at around 9.00 p.m. when the internal phone kept ringing and there was no one on the other end. She found it very unnerving, and rightly so, as Emily assured us that it shouldn't be possible unless someone else was in the building making the call.

Our unforgettable night at the York Dungeon was over and we couldn't thank Krissi and Emily enough for giving up their Saturday night for us. We thanked them both sincerely and headed out into the night. It was 1.20 a.m. but still warm, and we reflected on our evening as we passed through the crowds of revellers still partying on into the early hours.

CHAPTER SEVEN
DEAD MAN WALKING

Haunted – 08/10/11

'This is going to be the big one!' said Rich as I drove the north-east's favourite spook-searching quartet south once more to York. The 'big one' that Rich was referring to was tonight's venue, THE most haunted building in York: Haunted, 35 Stonegate. I couldn't help but agree with his excitable outburst, as ever since the conception of the idea of tackling ten of York's most paranormally active locations Haunted was right up there at the top of my wish list.

It had been a few months since our last foray into the world of the paranormal, and it would be Rich's first investigation as a married man, having tied the knot to his long-term girlfriend Amy a couple of months earlier. She's a lucky, lucky creature indeed to have bagged our Rich. The wedding reception was brilliant, with a very drunk, and usually very reserved, John asking the DJ on several occasions if he'd play Ghostbusters by Ray Parker Jnr. After the fifth time of asking the DJ caved in and when those unmistakable opening few notes flowed from the speaker system the place erupted. If truth be told that's not quite how it went down; the four of us were loving it with Tom strutting around the dance floor with an 'air proton pack'. The really drunk people seemed to be loving it too although I'm not sure that most of them knew what they were dancing too, but most people were a bit confused as, let's be fair, it's not on your typical wedding playlist. While we're on the topic of good news we'd also found out over the summer that Andy, our close friend and former teammate from way back in Chapter One, is expecting a baby at the end of the year with his lovely girlfriend Lisa.

It was a fairly average autumn day, not too cold, but there was a constant drizzle which didn't look like stopping anytime soon. We were making good time on our journey, we'd left a little later than planned with Tom being typically late, but I was confident we'd be in York in more than enough time for us to check into our hotel and get something to eat and drink before our investigation begins.

Tom told us that he had previously searched online for Haunted and told us that there are fourteen separate reported ghosts. 'Imported ghosts?' I asked, pretending to mishear. 'Where did they get them from?' 'Reported,' he quickly corrected me. He also pointed out that he struggled to find much about the place at all, and he was dead right, none of the ghost walks seem to include the location, and I've got dozens of books on the ghosts of York and it's not mentioned in any of them. It seems amazing that such an active building right in the centre of the city could be so unfairly overlooked.

I told the guys what I knew of Haunted. The current house dates from 1482, but the site upon which it stands has had over 1,000 years of continued habitation. For over 200 years the medieval building was a publishing house named 'The Sign of the Bible' of which the hanging wooden bible still hangs over the main door to this day. In September 1835 Princess Victoria, later to become the Queen, visited the shop when she was aged only sixteen and declared the business as 'Printsellers by Royal Appointment'. In 1873 Robert Sunter, the final heir to the publishing house, passed away and the building was bought by John Ward Knowles, a prominent stained glass manufacturer, and he renovated and redesigned it and it became the Knowles family home for the next 120 years.

Jonathan Cainer, one of Britain's top astrologers, took over the building in 1999 and when interviewed by the *York Post* at the time he said that he was aware of only a handful of spirits within the building, but during extensive renovations which involved digging in the foundations something happened. Thereafter the building was full of activity; Jonathan said. 'Suddenly we couldn't move for spectral figures, it was like Piccadilly Circus.'

Cainer and world-famous cutlery bender Uri Gellar opened it as The Psychic Museum in 2003. Television medium Derek Acorah carried out a live televised investigation at the Psychic Museum in January 2006 as part of his *Derek Acorah's Ghost Towns* programme for Living TV, and viewers nationwide watched on in horror as in the Séance Room he was attacked by an angry male spirit which grabbed Derek around the throat and threw him up against one of the panelled walls. After the attack had subsided Derek was told by his spirit guide Sam that this phantom is a very powerful man, aged around forty, who was angry that these people had invaded his space, Sam added that the man had so much hatred for the team that he'd love to rip out their hearts.

Haunted.

The house has since changed hands, as well as changed names to Haunted, and tonight the four of us would be tackling the majestic old building which has sent much larger groups of much more experienced paranormal investigators fleeing in terror.

Just after 3.30 p.m. we arrived at our accommodation for the evening, The Days Inn hotel at Wetherby services, eleven miles outside of York. The horse racing at York was on today and the hotels and B&Bs were all really busy, with most of them being fully booked, and the ones left were really expensive. I'd never stayed at a hotel at the services before, but it looked fine from the car park and it was handy if I fancied popping next door to Burger King, M&S, or WHSmith. It looked even nicer from the inside as we entered the foyer, with big comfy chairs, tables and a dining area. Rich had stayed here before and had already assured us that the breakfasts were 'to die for'.

We got the key cards to the two twin rooms I'd booked a few weeks earlier – 132 and 133 opposite each other on the first floor. I was rooming with John and Tom was in with Rich. The rooms were very well appointed with a nice big flat-screen television, comfy looking beds (that were far too close together, it was more like a double, so I quickly rearranged the furniture and moved them apart) and bathrooms that were nice and clean. However it was 3.45 p.m. by now so there was no time to enjoy these creature comforts. We wouldn't be returning until early in the morning so repacked our bags, only taking with us the things we'd need for the remainder of the afternoon in York and the investigation.

We got back into the car but as we neared York there were traffic jams in and out of the city, and once we finally managed to get into York the car parks all seemed to be full. After an hour of sitting in stationary traffic playing the 'name the artist/band on the radio quickest to win a point' game to pass the time, we gave up on finding a parking space in the city centre and headed to a car park we knew only too well; the large car park next to Bar Convent on Nunnery Lane. We easily found somewhere to park, but by now it was after 5.00 p.m. The only too familiar walk into the city centre took around twenty minutes. We passed the Hog Roast on Goodramgate so John popped in and got a sandwich and roast potatoes.

The shops were all closing by now and the last of the sunlight had made way for the moon to come out, and night time fell like a net. We went to the Cross Keys for some drinks and a hearty meal.

We left the Cross Keys at 7.10 p.m. and walked along College Street. There was a group of around twenty people huddled together in the rain, which was much heavier now, taking in one of York's many organised ghost walks. They were standing way back from the street under a tree and it looked very atmospheric as they were in almost total darkness with the only light coming from lanterns that a couple of members of the group were holding. The guide was telling them one of York's great ghost stories, the girl who haunts 5 College Street; she is seen crying at the window to this very day having starved to death in the house when her parents died of the plague.

We walked past the magnificent York Minster and onto Stonegate, one of York's best known and most historic streets, having appeared on records as early as 1118. It is built on the Roman road *Via Praetoria*. We stopped at No. 35 Stonegate, the building we would be inside in under an hour; Haunted, with, as Tom had told us earlier today, at least fourteen individual spectres said to lurk in the shadows.

We spent a bit of time looking into the front window – all the lights were off inside, we watched the four webcams that overlooked the Lantern, Séance, Mask, and Dining Rooms, and that people would later be able to watch us on through the same window, or via the wonders of the internet.

We popped into the Punchbowl pub further along Stonegate for a quick drink as at 8.00 p.m. we'd be heading back along to Haunted. The Punchbowl itself is said to be home to many spirits other than those behind the bar; the ground floor of the bar, where the four of us were currently sat, is haunted by the ghost of a fisherman who used to drink there in the nineteenth century – his name is lost to time but he is affectionately known as Frederick. He is fond of playing practical jokes on staff and customers, such as knocking glasses off the bar and off shelves. He has been blamed for doors opening and closing by themselves, and even moving the furniture around in the middle of the night when the bar is empty.

The cellar is believed to be home to a former landlord who died in a fire at the public house, and staff can tell when he is around as they get the unsettling feeling that they are being watched, often accompanied by the strong smell of smoke.

The uppermost bedroom is said to be the lair of a malevolent spirit, which has terrified staff so much that many refuse to go into the room alone. This is attributed to the murder of a young prostitute in that room at the hands of a dissatisfied patron back in the sixteenth century, at which point the pub was run as a brothel. People have complained of hearing banging on the walls when the room has been empty, and the room always feels cold, even on the warmest summer's day. A former landlady was in the room alone when she was suddenly grabbed by an invisible pair of hands and dragged across the room by her hair. On a different, but no less sinister occasion, a chef ran from the building, refusing to work at the Punchbowl again, after feeling a strong pair of hands around his throat.

We approached the entrance of Haunted at 8.00 p.m. and Georgia, our host the evening, was waiting to greet us. Georgia invited us inside out of the rain and we introduced ourselves. She took us into the room she suggested we use as a base; the room the daily tours begin in. Georgia kindly offered us a preliminary tour of the building, so we left our bags in the base room and followed her into a corridor at the foot of a long, winding staircase.

Only a couple of minutes into the tour we had our first unusual experience, or rather Rich did as he felt as if he was pushed upon reaching the top of the staircase leading into the Lantern Room.

We passed through the Mask Room, Lantern Room, and Dining Room and when we got to the Séance Room Rich had another unpleasant incident, a sensation he hadn't felt in almost a year since the National Railway Museum. He quietly told me that he felt the same unbearable panic in that room as he'd felt on the railway bridge. Georgia told us that despite what we might hear or read elsewhere the Séance Room was never used for séances in Victorian times, it used to be the Mistresses' bedroom.

During the tour she also offered us the chance to do something that she told us no previous group had *ever* done; we could investigate the Attic. She explained that all of the other rooms in the building are well presented as they are part of the public tours, but this room has simply been left. It is mainly used for storage, and she has only been in a few times as she tries to avoid it. We were all very excited by this prospect. However,

Rich and Tom in the Dining Room during our initial tour of the building.

my excitement was tinged with a hint of trepidation, as I knew something that the other three didn't about the Attic; visitors and other paranormal investigators who've not been 'lucky' enough to get into the Attic itself have reported hearing the terrifying screams of a woman emanating from the room. I decided to keep this to myself for now.

Tom asked if there was any room in the building Georgia wouldn't go into alone, and her immediate reply was the Cellar, and on that note she led us downstairs to that very room. As we descended she explained that they aren't allowed to change or move the staircase as it's the only example of its kind in Europe.

In the Cellar Georgia showed us another door leading out into an eighteenth-century enclosure beneath the street of Stonegate. She said anyone brave enough to stand outside in the small area would be standing on the original Roman level of the street.

By 8.30 p.m. we were back at base, the room in which the daily tours begin, and Georgia told us would have been the Drawing Room of the Knowles home where guests would have been received. It has large ornate stained glass windows that were designed by John Ward Knowles and remain in perfect condition. When the building was renovated in more recent years this room had such a rotten floor that it was possible to get permission to conduct an archaeological dig with a three-foot-deep pit. It was discovered that the building stands on top of a Roman refuse dump, but, as they say, one man's junk is another man's treasure. This was only too true as it was an Archaeologist's dream, almost spilling over with well-preserved Roman artefacts as well as some remains from the time of the Viking occupation of York.

Georgia gave us a two-way radio in case we needed to contact her throughout the night, and showed us where the office was that she would be based in. Rich asked if the lights could be left on until 9.00 p.m. so we could have another walk around the building ourselves to photograph and explore the various rooms before getting our investigation underway.

We spent ten minutes in each the Lantern Room, the Dining Room, and the Séance Room, before heading back to base just before 9.00 p.m., at which point Georgia radioed us to let us know all of the lights would now be going out.

Tom has an app on his iPhone called Night Recorder which records constantly but only saves audio clips with unexpected sounds so we decided to position this in the Séance Room while we investigated some of the other rooms. Tom, Rich and John headed there while I decided to wait alone in the room we were using as the base, a room which is said to be haunted by at least two spirits: an unidentified woman who is seen passing through the room very quickly, and a girl sitting in the corner alone. People like to believe this is young Princess Victoria, but cannot be sure of her identity. I felt fine, although once the sound of the other guys climbing the staircase faded away to silence, the lack of any kind of sound whatsoever was a little unnerving.

Once the others returned after five minutes I rejoined them and we headed down to the Cellar to place some trigger objects in the form of stacked coins atop a piece of paper on which the coins are drawn around so that if there's any movement it can be identified. John's biggest concern in the Cellar wasn't the entities believed to haunt the room, it was something far more of this world – spiders. John is absolutely terrified of spiders and in the Cellar there were lots of them. Thankfully for John we were only in the Cellar for five minutes before returning to the creepy crawly free safety that the base room offered.

Rich suggested we split into two groups, and that he and I spend some time in the Lantern Room while John and Tom go to the Dining Room.

The Lantern Room is a fairly small rectangular room with the original beams built into the white walls, and low beams with lanterns above them hanging down from a high apex ceiling. A wooden bench at the far side of the room resembles a pew from a church, and a bench with a cloth covering sits against the wall opposite a fireplace built into the chimney breast, which has a decorative battle axe affixed to it.

Rich and I sat on separate benches and turned on our recording devices. We turned off our torches plunging us into total darkness; the only source of light I could see was the red lights coming from the night vision webcam high up on the ceiling above me. As Rich began to ask out for whoever may be with us to make themselves known, I suddenly, and unexpectedly, felt on edge as if I was being watched and that I most certainly wasn't welcome, and if I'm honest I just wanted to get out of the room. I didn't say anything at the time and continued to sit in silence as Rich continued to attempt to make contact. After three minutes the sensation I had felt disappeared as quickly as it had come over me. At 9.45 p.m., twenty-five minutes after we'd came into the room, we headed back to base to meet the others as agreed with no results to any of our attempts to stir up some activity. As we descended the staircase back to base I told Rich how uncomfortable I'd felt when he'd started talking.

The other team were ten minutes late arriving back at base, and I'd hoped that this was due to them getting a result in the Dining Room. Unfortunately, though, they'd had as little success as us. We took a short break, having a drink and eating the Haribo Spooky Ghost sweets I'd brought along for the lads as a little treat, as we discussed our next move.

Rich was keen to return to the Séance room where he'd felt panicky on our earlier tour with Georgia. With it being a large room and there being twelve seats around the table we agreed to stay together and the four of us headed back upstairs just after 10.10 p.m.

The Séance Room is a panelled room of which all of the carved wooden panels are original or restored and depict all manner of symbolism from flowers to demons. The

room was used as the Mistresses' bedroom, but is now made up like a Victorian séance room with a large round table, which dominates the room and is so large it had to be made inside the room. On the table are three Ouija boards and in the centre a very heavy, very elaborate crystal ball.

Georgia had earlier told us that there is a secret room hidden within the panelled walls which can clearly be seen on the plans, but it's believed has now been lost since the Knowles restructure at the end of the nineteenth century. As Rich, Tom and I picked a seat; John was keen to use a spirit level on both the floor and the table, as many believe that uneven floors can account for some reported paranormal phenomena. He was happy, however, that both the table and the floor were level.

We spaced ourselves evenly around the table, and Tom picked up the glow-in-the-dark Ouija board before him and said 'It says here this Ouija board was made by Hasbro, didn't they make the Transformers toys?'

The Ouija board, made up of the French and German words for 'yes' was invented in 1890 as a parlour game. However, during the First World War the American Spiritualist Pearl Curran popularised its use as a genuine means of contacting the dead, with her herself famously making contact with a seventeenth-century poet by the name of Patience Worth. In 1924, the world-famous magician Harry Houdini cast a shadow over the safety of using the boards when he wrote of five people from California being driven insane after using the Ouija board. In the years and decades that followed doctors noticed altered states of mind in regular users of the boards, and in a number of documented cases this was so severe that the user was committed to an asylum.

26 December 1973 saw the cinematic release of the classic horror film *The Exorcist* and this proved to be the defining moment in the decline of the Ouija board. In the movie a twelve-year-old girl, Regan, contacts a demon calling himself Captain Howdy through the Ouija board and becomes possessed with disturbing results including the death of several characters.

The cinema-going public had never before seen a film so terrifying and so powerful, that it caused mass panic and hysteria worldwide with many cinemas across the UK refusing the show it. This led to entrepreneurial travel companies putting on Exorcist Bus Tours taking people brave enough to the nearest town showing the film. The cinemas showing the movie had queues around the block and ambulances on standby as a great many cinema goers fainted or became hysterical, and those who didn't rarely managed to stay until the end credits. *The Exorcist* is still widely regarded as the scariest film of all time, and this combined with stories, which have since been confirmed as fact, of the film being based on the very real possession of a young boy, and a mysterious fire during filming that consumed the set, brought about the widespread belief that the Ouija board is in fact a portal to Hell.

Church congregation numbers swelled in early 1974 with the petrified public wanting to know how to avoid suffering the same fate as the poor young American girl they'd seen on the big screen. The Church's stance was, and still is, that the Ouija board is the dangerous, unholy tool of the Devil. When loved ones pass on they are no longer permitted to speak to the living, they remain silent until you are reunited with them in Heaven. Therefore if you do make contact with 'something' through the Ouija board, even if they claim to be a dead loved one, you are in fact communicating with

One of the
Ouija boards
in the Séance
Room.
(Photograph by
John Crozier)

an evil spirit, possibly even Satan himself. These spirits will try to mislead you and deceive you, and if you let them into your life you will never be free of them. People were burning their boards and shunned toy stores that stocked them.

To this day the Ouija board has failed to shake off its sinister connection with evil and the dark side. Despite this, they are widely available, with online retailers stocking them for as little as £9.99 and Ouija is indeed a registered trademark of toy manufacturers Hasbro.

We'd been on the daily tours at Haunted and as a result knew that there would be the opportunity to use the boards on our investigation. We'd discussed it earlier in the day, and Rich was against the idea due to a bad experience he'd had earlier in his life. Out of respect for our teammate and friend, we all agreed we wouldn't use them.

John, Rich and I pressed record on the three voice recorders we had with us and we turned off our torches, the only light coming from the red dots on the webcam on the ceiling and the eerie green glow from the luminous Ouija board in front of Tom. Rich began to explain aloud to any spirits with us who we were, why we were there, and asked for some kind of sign that we weren't alone. At that very second the silence was shattered by a loud vibrating and beeping – Rich's mobile phone receiving a text. This made everyone jump for a moment but burst into laughter once we'd realised what it was. I asked if that was a text message from beyond the grave but it turned out to be Mrs Stokoe dropping her new husband a good luck text.

Order restored, and Rich's phone now on silent, we continued our vigil. Tom, John and I sat in silence as Rich led the session. Thirteen minutes passed with absolutely no response to any of our questions so we discussed bringing it to an end; however, as we quietly talked it over Tom suddenly said 'What was THAT?' He explained he'd heard, and felt, a loud bang on the floor which seemed to come from between where he and John were sat. John confirmed he'd heard it too but he hadn't moved and was

sure he'd not made the noise. Our enthusiasm renewed, we made the wise decision of carrying on, and I'm so glad we did.

Tom picked up where Rich had left off by asking aloud, and before he'd even finished his next question Rich said 'Did you feel that?' John, Tom and Rich had all felt what Rich described as being a hard stomp on the floor; however, I didn't feel it. As they were discussing it, it happened again and this time all four of us felt it, then as we were discussing this second 'stomp' it happened again, then again, and again with such regularity that it almost seemed like the footsteps of someone in the room with us. John, as always, tried to come up with a rational explanation, suggesting it may be the bass of the music from the nearby pub, but after sitting in silence for a few minutes I said that the music didn't seem to be that loud, and I didn't feel or hear any more bangs during the period of silence, so we all agreed it seemed fairly certain that it couldn't be attributed to being something outside of Haunted. We began to ask out again with immediate responses in the forms of footsteps, I couldn't feel or hear them this time and Rich suggested I swap seats with him as he felt like someone was walking back and forth behind him. After swapping I still couldn't feel anything but John said that he could now feel constant vibrations in the floor around him. All of a sudden, and without warning, I felt like the darkness was consuming me and I felt sick, it was then I heard and felt what I'd been hoping for and dreading in equal measures; footsteps behind me, walking from right to left before vanishing as quickly as they'd appeared. The sickness I felt disappeared but was replaced by an icy chill in the air all around me that was so cold my teeth began to chatter.

We had five minutes of inactivity before the 'stomping' started again, and then we heard a new sound – a series of knocks which seemed to come from the wall to the left of where I was sat (which is the wall on the right when you walk into the room). Then Rich said that he felt a cold spot around him just as I had earlier, and then we felt and heard the footsteps again, it was as if someone was circling us. The cold spot seemed to be making its way around the table, which was following the footsteps; John then said that he felt

Tom, Rich and
John in the Séance
Room.

freezing cold, with every hair on his body standing on end. At this point Rich said things seemed to be getting out of hand and that he'd like to turn on a torch to give us a little light so we could see if we could see anything in the room with us. He picked up his torch and turned it on but bizarrely after a few seconds it glowed really intensely, far brighter than it is usually lit, and then faded out completely. The room was lit up again as the torch flickered on and off as we all looked on, gobsmacked by what was unfolding before our eyes, it then faded out again. Rich tried turned the torch off and on but nothing happened. It was as if whatever was with us didn't want us to be able to see 'it'.

Over the next three or four minutes we sat quietly in the dark and all felt footsteps walking around in the room with us, I now felt so sure that I was being watched and asked if anyone else felt the same, Rich promptly agreed.

We'd had the most amazing thirty minutes of any investigation I've been involved in my nine years of doing this, but just as suddenly as the knocks, footsteps and cold spots had begun they stopped and were replaced by an overpowering musty smell, like the odour of an old house that hasn't been disturbed in decades. Just as we thought our scares had come to an end for now we got the biggest fright of all; we were sat in silence when an incredibly loud interference-like noise came over the radio. We all jumped, and there were at least one of two 'curse words' shouted out. Tom and I clicked our head torches on, and John, who had the radio in his shirt pocket, seemed to be having some kind of panic attack, swearing loudly over and over while holding his chest. Once the commotion had settled down the radio sounded again; this time would could make out a woman's voice, which wasn't very clear, but she was saying 'Are you alright, do you need any help?' John responded saying 'we can't hear you very well so will come and see you in your office, over', there was a distorted response from the same female voice but we couldn't make out what she was saying.

Tom and I headed for base while John and Rich went to see Georgia. However, they were surprised to discover that she'd made no effort to contact us all evening other than at 9.00 p.m. to let us know the lights were going out. She said that it is possible it is some kind of interference from a nearby business, but we can't be sure. She accompanied John and Rich back to base to see how things had gone so far.

Rich told Georgia that we'd spent time in the Lantern Room and Dining Room with little success, but the Séance Room had been a major result with such a flurry of constant activity for almost an hour that it had left all four us in a state of almost disbelief. I personally was a little distracted as I desperately attempted to rationalise the experiences that Rich proceeded to tell Georgia all about; the definite footsteps which we had all independently felt and heard, and which seemed to be moving around the table, and around us, with purpose; the cold spots which seemed to follow the footsteps; when Rich felt he needed some light what exactly happened to his torch, which was now working perfectly fine. As Rich spoke Georgia smiled knowingly and nodded.

That makes sense, and those are all things that have been reported in that room before. As I said earlier the room was the Mistresses' bedroom, and it was a very private location as very few people would ever be allowed inside that room, so the master of the house is anything but happy to have dozens of people passing through the room on the daily tours, often with twelve people sat around the large table in the

room. He walks around behind people with the intention of imposing his authority as even today he still considers this building to be his home and he wants to ensure that people don't forget that he's still about.

There's a second ghost associated with the Séance Room, a young servant girl who fell pregnant to the master. She gave birth in the room which is now the Lantern Room, but sadly the baby was stillborn. Fearing his wife would learn of what had happened the master threw the servant to her death from a window of the Séance Room and she has remained bound to this room ever since. Sadly she doesn't realise she is dead and she is a very tragic, lonely figure.

I'm surprised you didn't have any success in the Lantern Room, as that is a room with a lot of history. Much earlier in the building's history that room was actually part of the Monastic building next door which was built by the church for the monks of York. The monks used to pimp out local girls on Grape Alley, a dark alley not far from here, which in the fourteenth century was called Grapecunt Alley, with grap being the Old English word for grope as that's what men would come here for. When the room became part of this house it was used as a servants quarters, and it was in this room where the birth of the stillborn baby happened. The main spirit known in this area is that of a matron, a bossy woman who has been known to push and pull visitors in that area, as in life she would have been responsible for making sure the servants were where they were meant to be.

On hearing this Rich spoke up about being pushed just outside of the Lantern Room on the earlier walk around, something that came as a surprise to Tom and John, as I was the only person he'd told, and now it seemed he may have had an encounter with the Matron as it sounded very similar to what Georgia had just described.

The Dining Room has naval connections and a lot of mediums to the building pick up on this. It is feasible that there was a gentleman master here at some point connected to the navy, however it's also believed that there may be a different connection, that when the room was restored in more recent years it was done so with wood taken from shipwrecks and this has somehow stirred up the activity within the room.

At 11.30 p.m. Georgia wished us luck as she headed back to the office, and the four of us headed back down to the Cellar, much to John's reluctance. The Cellar somehow seemed darker now, and it was undoubtedly much colder than it had been earlier in the evening. We checked on the trigger objects but unfortunately they'd not moved. 'Why don't we try the human pendulum down here?' asked Rich, an experiment we'd had limited success with on our previous investigation back in July at York Dungeon. Everyone was open to giving it a try and Rich offered himself up as the pendulum. He took his position in the centre of the floor, arms outstretched, feet close together and Tom stood in front of him and John behind. Tom spoke out to the spirits with us in the room asking for the sign for a 'yes' answer to be a forward motion, and for 'no' Rich should fall backwards. As Tom proceeded to ask questions I left them to it and, unbeknown to the others, decided to spend some time alone in the enclosure beneath Stonegate, the area that Georgia had suggested we might want to check out 'if we were feeling brave'. I stood in the doorway and shone my head torch into the hollow. Now

don't get me wrong, I'm not scared of spiders anywhere near as much as John, but I don't like them one bit and it appeared no one had dared to go beneath Stonegate in a while, as everywhere I looked there were gigantic cobwebs, home to gigantic spiders. Ah well, nothing ventured, nothing gained. I turned off my torch, plunging myself into absolute darkness and tentatively made my way into the pitch-black opening beneath the ancient street.

After only five minutes, which seemed like hours, I left the dark hollow, which had been surprisingly quiet considering it was late on a Saturday night. The street above had been fairly noisy with late night drinkers coming and going from pubs such as the Evil Eye Lounge which is almost opposite, and the Punchbowl.

I sat down on a chair next to where the others were still conducting their human pendulum experiment, and they were having some success as Tom continued to ask out.

'Did you live in this house?' The answer was yes, as Rich fell forward, John catching him as Rich came to. As he retook his position he said that he felt like he'd been pushed in the back.

'Did something bad happen to you here?' Rich fell forward, signalling a yes.

'Were you killed here?' Again this was a yes, with Rich falling forward with force, John struggling to catch him.

We continued to ask questions, with the spirits providing answers via Rich to each one. We established there were four spirits with us, one of which was trapped here as he, or she, was murdered in the Cellar.

Rich and I swapped places and I closed my eyes, held my arms out and tried to zone out, breathing deeply and clearing my mind. Rich told me that it had been an unusual sensation, like a build up of pressure to the point where he couldn't help but fall. John was in front of my and Tom behind. I barely even heard the first question Rich asked:

The human pendulum experiment; one of the many spirits at Haunted communicates with us via Rich.

'Are there four spirit people with us' I felt like I had been in some kind of a trance as John caught me, I couldn't even remember falling, but I heard Rich say 'so that's a yes, there's four spirits with us'.

'We are friendly and we come with respect, are you friendly?' Tom caught me, as I'd fallen backwards signalling a no, and terrifyingly this meant that I was being pushed backwards and forwards by spirits that had just told us that they weren't friendly.

'Are there spirits here in this room that are good and don't mean us any harm?' I fell back again signalling a no.

Rich said 'there's negative energy here', and we agreed that we shouldn't continue with the human pendulum with the risk that the spirits who were controlling the pendulum could attempt to harm us.

I was still coming around and we heard screaming coming from nearby; however, it wasn't in the room with us, or even in the building, it was some drunks fighting on the street outside.

On the back of some impressive results with the human pendulum we decided to try and make contact by attempting another experiment that we tried for the first time at the York Dungeon, one that was unique to our group as it was of John's design; standing in a circle with a gap between John and Tom, then inviting whoever might be with us to join the circle. We pressed record on the three separate digital voice recorders and John would ask a question 'What is your name?' We would go around the circle taking turns to answer in the hope that when it reaches the gap we capture an answer on the voice recorders. It was definitely worth a try after the success with the human pendulum. Unfortunately, upon listening back to the recordings there was nothing out of the ordinary.

We hadn't given up on the Cellar so I suggested we simply spread ourselves out around the room and sit in silence for maybe ten minutes and just see what we could hear, see, feel, or smell. Tom bravely said that he'd like to tackle the hollow beneath the road, so it was agreed John and Rich would sit in the Cellar and Tom and I would spend some time in the two small areas beneath Stonegate on the level of the old Roman road. After only a couple of minutes Tom said he heard a noise behind him, but on further investigation it was water dripping. Shortly afterwards I felt something climbing up my leg, in a bit of a panic I tried to brush whatever it was off me, then put my torch on but I couldn't see what it had been – probably for the best if I was to have the nerve to spend much longer in that spot.

Ten minutes passed, frustratingly without anything happening whatsoever. I checked my watch and it was after midnight. Prior to the investigation the Cellar was the room I was most excited about spending time in, but rather reluctantly we agreed we had to move on as there was still plenty of the house we'd still not explored yet, and we were determined to spend more time in the Séance Room.

Back at base we took the weight off our feet and I commented on how much the temperature had dropped as I poured myself a hot cup of coffee from my flask, the steam passing through the beam from my head torch. We briefly discussed how we felt the evening had gone so far, but we knew with only a couple of hours remaining at Haunted, we'd have plenty of time for reflection tomorrow, what we needed to do now was establish where we were going to go next.

Shortly afterwards we were headed to our next locations. Rich and Tom were going to the Mask Room. When the Knowles family were here it was a library, but now the room is named for the decorative masks adorning every wall. A lot of people feel the need to watch the masks, as if they don't trust them, especially on investigations. The masks have all been used at some point – they aren't decorative, some will have been used in ceremonies and they are from all over the world – and some believe that the activity in the room may be associated to the mask's actual usage in the past. Some of them are pretty old, and a lot of them were found in the house the current owner took over.

John and I were going to the room next to the Mask Room, the Mirror Room. The Mirror Room is rather unusual in that all of the walls are mirrored, hence the name, as is the ceiling. The only exception is the curved wall on the left when you enter the room, upon which an image of the visitor is captured and projected onto the wall and is said to show them their aura. There have been some unusual things seen in the mirrors and on the projection wall, one of the most common being a bicycle propped up against the wall. Georgia would later tell us that the room was used as a drop through for deliveries for the kitchen.

The room is fairly small and there are no seats. John and I took a lot of photographs into the mirror as some paranormal investigators believe that we can see things in mirrors that we can't see in the room with us at the time. I'll never forget a Religious Education lesson I had at school when I was eleven or twelve, and someone asked the teacher 'Miss, do ghosts exist?' She replied 'I honestly can't answer that, but I'd suggest you try to avoid looking into mirrors after dark!' As a child that chilled me to the bone, but twenty years on and that's precisely what I was doing and it wasn't just any mirror, it was a mirror in the most haunted building of the most haunted city in Europe.

Ten minutes passed by uneventfully, so we joined Rich and Tom next door in the Mask Room. I sat down next to Rich and they continued with their session. After

Above left: Rob in the Cellar. (Photograph by Tom Kirkup)

Above right: Tom and Rich hear something in the Mask Room.

a couple of minutes Rich and I both said we felt cold at the same time, and rather bizarrely we simultaneously had an itchy back.

At 12.30 p.m. we moved to the Attic, the room that we would be the first group to ever investigate. Georgia would later tell us that this room was used as sleeping quarters for female servants and their children. Due to it being a room that very few people ever go into it was fairly empty with wooden chairs down both sides of the wall, a book shelf with an assortment of hardbacks, and Haunted fliers (by that I mean fliers promoting Haunted and offering a rather generous discount, rather than them actually being haunted, groaning and flying around the room) piled high on a couple of the chairs.

The Attic sadly proved to be disappointing, but perhaps if we'd had more time or we get the opportunity to return we might have been fortunate enough to experience some of the happenings which Georgia told us has turned sceptical members of staff into firm believers once they'd spent some time alone there.

With time now being at a premium, we decided our next move while we were in the Attic rather than returning to base. Rich and I would spend twenty minutes in the Dining Room, and Tom and John would go to the Lantern Room.

Opposite the door into the Dining Room is a large bay window with a seating area and you can look along the length of the ancient street below. The curtains are always open so there was light coming in. The street was very lively, as you might expect on a Saturday night in the centre of York. Above the fireplace there was a stag's head on the wall, which Tom had earlier nicknamed Bambi as he had found it creepy. There were also many paintings and a highly decorative ceiling above us. Most interesting to us, however, were two large mirrors on opposite walls, as on our earlier tour Georgia had pointed these mirrors out and said that people often see figures in the mirror that they can't see in the room with them.

Twenty minutes passed by without anything of note happening, and we met the others back at base to find they'd found the Lantern Room as quiet as Rich and I had earlier.

At 1.15 a.m. it was time to return to the Séance Room, something we were all a little concerned about given what Georgia had told us, as it seemed likely we'd been in the presence of the master of the house earlier, a powerful entity who didn't want us there. I led the way as we climbed the staircase approaching the room and John did nothing to put us at ease when he said 'Did anyone else just feel like there were five people walking up the stairs there rather than just us four?' We all stopped and looked at him, and he said that 'When Rob turned around there I caught a glimpse of five shadows in the beam from his torch, rather than just us four'.

We spent forty-five minutes in the Séance Room with the same amazing results as before; cold spots and footsteps moving all around the room. This time the activity came and went in a five-minute spell between 1.35 a.m. and 1.40 a.m.

At 2.00 a.m. it was time to draw our investigation of Haunted to a close and as we made our way downstairs and back to base where Georgia was waiting for us I passed comment to the others on the incident with Rich's torch almost three hours earlier, pointing out that it had worked perfectly without a single flicker ever since.

Back at base we chatted with Georgia about how our evening had gone. We told her of our disappointment by the Cellar, and she was surprised as she said there's usually

a lot of activity down there, although some of it may be psychological as it's a dark, scary room at the base of a dark, scary house. She also filled in some of the blanks around the history of the room. In the 1600s someone was chained up and left to die in the hollow beneath Stonegate. Their remains were hidden for a very long time with the chains only being found in the last century during refurbishments by the Knowles family to turn it into a kitchen. During the First and Second World War it was used as a soup kitchen. Rich mentioned our Human Pendulum experiment and that we'd appeared to make contact with someone who said they were killed in the room. We all wondered if that had been the same tragic soul Georgia had just told us about.

Tom asked if she knew anything more about the secret room in the Séance Room. Georgia answered that from the plans of this building and the building next door it appears to be the wall on the right when you walk in. However, due to the panels being listed it isn't possible to investigate further and see what lies behind the wall, perhaps some dark secret walled up and hidden from plain view for hundreds of years. We may never know. I found this interesting considering the knocking we'd heard appeared to come from on, or behind, that same wall.

We said our goodbyes and the four of us stepped outside to be met by a cold and very wet night. It was raining very heavily and we had a twenty-minute walk back to the car. We were glad to get into the warmth of my car. We were soaked through, and all ready for some sleep. I drove along the almost deserted roads back to Wetherby and we got to bed for 3.00 a.m.

A few days later when typing up my notes I stumbled across something online which stunned me; on 3 September, just over a month before our investigation, a large group spent the night at Haunted and they, just as we had, found the Séance Room to be the epicentre of the paranormal activity within the house. They experienced some odd things there – vibrations in the floor accompanied by the sound of footsteps, cold breezes around them, and then during the activity a torch flickered on and off. Does this confirm that what we had experienced was definitely something paranormal, or does it mean that there is something about the Séance Room which causes these happenings naturally? I'll leave you to make your own mind up on that one.

The team in the Séance Room, as seen through the Haunted webcams.

CHAPTER EIGHT
FOUR-STAR SCARES

Middlethorpe Hall Hotel – 27/10/11

'This sure looks haunted' said Rich to no one in particular as we approached the entrance of the four-star Middlethorpe Hall Hotel. He was right; I'd seen many photographs of the Historic House Hotel which dates back to 1699, but none of them do the building justice. It is mightily impressive, of that there is no doubt, but now we were face-to-face with it on a very dark, very wet October night it looked particularly formidable.

Tonight I was joined by Rich and John, as Tom wasn't able to attend due to work commitments. The porter opened the door for us and welcomed us to Middlethorpe Hall Hotel. We thanked him and approached the reception desk. The receptionist was taking a telephone booking, so as we waited patiently I gazed in awe at the antique furniture, the highly polished chequered marble floors, and grand oak staircase. It immediately became apparent why this was the hotel of choice for the rich and famous visiting York, with stars such as Russell Crowe, Gwyneth Paltrow, and members of the royal family all choosing to stay here in the twenty-seven years since the building was rescued from decay and carefully restored to the luxury hotel, restaurant and spa it is today. I was in no doubt that we were not their usual clientele. Rich was in hoody and jeans, and I may have looked slightly smarter, although I'd been in the shirt and trousers I was wearing since I left for work at 6.30 a.m., almost fourteen hours earlier, and it showed. John was also in shirt and trousers and, of course, his massive coat. All three of us were clutching Poundland carrier bags, having stopped at the Metro Centre in Gateshead for a bite to eat at Burger King and then stocked up on cheap snacks and drinks to keep us going across the next forty-eight hours; as if to complete the look, I had the *Viz* magazine tucked under my arm.

When the receptionist had finished taking his call he asked how he could help. I handed over the booking confirmation and said we're booked in the name of 'Rob Kirkup'. He handed over the keys to Rooms 2, 5 and 11, and as he did he asked with genuine interest, 'So you're the ghost hunters?' We had a chat with him for ten minutes or so and he said he'd never experienced anything, but he knew that other people had. This is something the three of us had discussed on the drive down to York, with John and Rich both saying that countless Google searches had brought up nothing at all about Middlethorpe Hall Hotel being haunted, plenty of sites about the hotel, and plenty about ghosts, but not a single site incorporating both. I've got countless books on haunted York and they wouldn't have found Middlethorpe in any of those either, as

it's generally not regarded as being haunted. Through word of mouth I was advised it may be worth checking out as there have been the occasional reports coming out from the hotel across the last few years of guests experiencing anything from cold spots right up to full spectral apparitions. The hotel is such an unknown quantity as one of York's many haunted hotspots that to the best of my knowledge we're the first group to ever investigate it.

Rich randomly handed out the keys, and as he did another friendly member of staff appeared behind the desk and wanted to let us know before we headed off to our rooms that they'd specifically set Rooms 2 and 5 aside for us, as that's where most of the paranormal happenings seem to have been. I looked down at the key Rich had only moments earlier placed in my hand. It had a big number 2 on it. 'Great, fingers crossed something happens in the room I'm staying in' I said enthusiastically, but secretly I wasn't all that comfortable with the idea. John had Room 5, and Rich had Room 11.

The porter said he would show us to our rooms, and offered to help us with our bags. We approached the majestic oak staircase, passing valuable paintings as we ascended. When we reached the first landing there was a huge door in front of us with a brass plaque on it reading 'The Duke of York Suite'. Above it was a number 2 – it was my room, and upon entering the three of us were taken aback by the sheer size and grandeur of the room. 'They must have run out of big rooms,' said Rich jokingly as he looked up at the chandelier hanging from the ceiling. We walked through the living room with an antique bureau, an ornate fireplace, a flat-screen television, a sofa and an armchair and two enormous bay windows. We then entered the bedroom which had another flat-screen television, a sumptuous-looking two-poster bed and two more bay windows. I was in *the* main suite in the entire hotel, the very room that the royals and global superstars will have occupied across the years.

The very friendly, extremely professional porter who showed us to our rooms told us he used to work at the Royal Oak in York for many years and had some extremely

Above left: Middlethorpe Hall Hotel.

Above right: The luxurious bedroom of the Duke of York Suite.

unusual happenings which left him in no doubt that the building was haunted. On one particular night he was inside a room when a dresser on the other side of the door, in an empty room, moved in front of the door, trapping him inside. He said he'd not personally experienced anything out of the ordinary at Middlethorpe Hall, but he knows for a fact that many guests have, this room in particular proven to be very active.

With those words reverberating around my brain, making me feel a little uneasy, they all left to be taken off to their rooms. It was 8.00 p.m., and we'd agreed to meet back at my room at 9.30 p.m., an hour and a half later. This would give us plenty of time to organise our equipment, change our clothes and take a breather, as all three of us had done a full day's work prior to jumping into my car and heading for York.

I kicked my shoes off and as I rang my wife I wandered into the bathroom. I decided to run a nice hot bath, the very bath in which *Shakespeare in Love* leading lady Gwyneth Paltrow will have relaxed in when she stayed here. Perhaps reading a book, or shaving her legs.

After my bath, I took my bag of equipment into the living area to sort through it. It was only at that point that I realised there was a letter for me on the table. It was a very thoughtful handwritten letter on high quality headed paper from the general manager, who'd been so kind in allowing us to stay. It was accompanied by another handwritten sheet with a list of all the reported paranormal phenomena room by room. I picked a few grapes from the bunch in the fruit bowl and read through them:

Room 2 – Previous maintenance manager reported his dust sheet moving while redecorating and a very cold draught on his back.

Room 4 and Room 5 – In both rooms guests have passed comment on feeling a presence during the night.

Ladies' Toilet (Basement) – My PA as well as a young guest felt a presence and then saw a lady wearing a 'Jane Austen' square necked, plain dress, and hair tied up.

Library – The daughter of the previous General Manager reported seeing a young girl (once again in period costume) playing with a 'whip-a-hoop'.

Spa – Our painter/decorator believes that a lady comes down the stairs at 3.00 a.m. and has reported having heard voices and banging!

I couldn't quite put my finger on the reason why, but I felt a lot more comfortable in the bedroom than I did in the living area, which creeped me out, and it wasn't as a result of reading through the list of inexplicable happenings. I checked my watch and it was just after 9.15 p.m. I opened a can of Cherry Coke and sorted through my equipment, my torch, my voice recorders and my camera, checking the batteries and taking a few photographs of my room before our investigation began.

John and Rich arrived at 9.30 p.m. as planned and Rich took a seat on the sofa next to me, immediately commenting on how comfortable it was. John sat in an armchair in the corner. Rich helped himself to one of the grapes from my fruit bowl. 'Wow, they're

good grapes,' he said, following it up with 'Do you want the apple?' I told him to help himself. It was time for the serious business to begin, we had already identified the areas we were going to spend time in, and we had a variety of experiments, including some new ones, that we were keen to try.

As always we set our voice recorders away as early as possible. I positioned a digital voice recorder in the bedroom and one on the table in the living area in which we were sat. John had brought an old analogue voice recorder which takes tiny cassettes and he placed it upon the bureau.

We also wanted to put a new experiment into practise – recording over 'white noise'. To do this we tuned the battered old radio I'd brought with me 'between' radio stations so all that we could hear was the static. I then took a brand-new, sealed cassette tape and put it into the radio and pressed record. The theory is that spirit can communicate in the white noise, although there are some who believe that this can be dangerous as the investigators have no control over which spirits come through, similar to conducting an Ouija board.

White noise was brought into the public eye in a big way by the 2005 movie of the same name starring Michael Keaton. In the movie Keaton contacts his late wife via white noise, but he soon attracts other entities including a number of demons which ultimately end up taking his life in a particularly grisly manner.

We turned the lights out, although we had some light coming in through the large bay windows casting the shadow of John sat in the armchair across the length of the room. Rich, once more our reluctant spokesperson, began to speak aloud. 'We are here in complete respect; we're looking for proof that there is life after death. If there are any spirits …' At this he was stopped mid-sentence by a loud bang from the bedroom which all three of us heard clearly. I cautiously went into the room to see if anything had perhaps fallen that could have made the noise, but I found nothing.

I was excited by such a promising start, but I also had the nagging concern that I would have to sleep in here all alone once our group investigation ended. I suggested that Rich continued to ask out for perhaps another bang. But Rich seemed preoccupied; he was staring at the floor and hadn't heard a word I'd said. I gave him a nudge and he suddenly sprang back into life. He told us he'd had the overwhelming feeling of someone walking past him, having walked in through the main door to the room, past him and into the bedroom. So strong was this sensation that he told us that if he'd looked up he'd have been more surprised to not see someone, then for there to be someone there.

No sooner had Rich finished explaining this, than both he and John spoke at the same time. 'Can you hear that?' I said 'What can you hear?' and they both said they could clearly hear voices talking through the static on the radio which I'd positioned next to the fireplace. I moved closer to the radio and turned the volume up slightly and there was no denying that there were at least two different voices coming through, male and female, although their words were indiscernible. We discussed whether it could be that I'd positioned the radio dial too close to a station and it was causing interference, although to be honest I had been very careful to choose a frequency which wasn't near to any other station. To be sure we agreed that I would change it from the AM frequencies that I was currently using to FM and carefully placed it at the lowest end of the scale nowhere near any other stations.

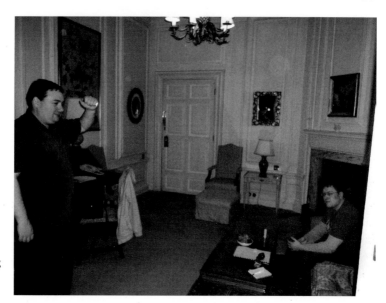

John and Rich
investigate the living
area of the Duke of
York Suite.

I again suggested Rich ask out, but before he could even respond we heard talking again. However, this time it wasn't from the radio, the voices were inside the room with us. It was a man and a woman talking softly. John checked outside on the landing but there was no one there. We listened for three minutes during which time the voices got quieter and quieter before simply fading away completely.

While we'd been listening to the very definite voices around us, I'd caught sight of movement out of the corner of my eye; however, when I'd turned to see what it was it turned out to be nothing more than a beetle on the wall (when I later told Rich of the beetle sighting he suggested I should call this chapter 'Resident Weevil').

Rich spoke aloud, asking for any spirits with us to affect us in some way, suggesting that they could perhaps try to alter the temperature around us. Again, we had an immediate response as John said he felt a cold breeze moving around him. He was sat closest to the window and it was certainly a chilly evening, so Rich and I suggested it might be as a result of that. He shook his head and said that he'd been sat there for close to half an hour and he'd felt nothing like this.

Despite Middlethorpe Hall Hotel being fairly unknown as an active venue, we were having constant, amazing happenings all around us and it was only 10.00 p.m. Because of the promising start to our investigation I suggested that it may be the ideal opportunity to try another new experiment for us; inspired by the Mirror Room at Haunted, our previous venue. I lit a small candle in front of the large mirror on a dressing table at the far end of the bedroom and Rich sat at an angle looking into the mirror so he could see the rest of the room using only the light from the candle. John and I returned to our seats in the living area and the three of us sat quietly.

After only a few minutes Rich said 'Rob? Are you moving around in there?' John and I looked at each other and it was clear John was as puzzled as I was, I responded with a very certain 'no'. Rich sounded a little alarmed and asked if someone could turn a light on. John turned the light on and we both walked into the bedroom to see what

Rich positions himself in front of a mirror to see if he can see a spirit moving around in the room behind him, unaware of what he would actually see shortly after this photograph was taken.

Rich had seen. Rich didn't turn to speak to us. He continued to look into the mirror as he'd explained what he'd seen. In the doorway between the two rooms he'd seen a figure sitting on the window ledge rocking back and forth, he said he could see it as clear as day.

We changed places, with John sitting in front of the mirror, and Rich joining me in the living room, choosing to sit on the sofa, so I sat on the armchair near to the window. We sat silently again. My eyes were drawn to the portraits above Rich, one of a well-dressed, obviously very important man, and the other of an equally well-dressed lady. I'd tried to avoid looking at either of them since I'd come into the room. It might sound odd but I had felt like their eyes were following me. My eyes were no doubt playing tricks on me in the darkness but it seemed to me like the woman in the portrait above Rich moved slightly. I told him and he quickly jumped up and said 'don't tell me that!' as he moved further along the sofa.

Almost twenty minutes later we agreed to move to the next room. We all agreed that the Duke of York Suite had been incredibly active, despite seeming to fade away towards the end of our vigil in the room. This had proved to be a bit of a double-edged sword to me personally as I was extremely excited by the definite responses to our questions, and the fact that Rich may well have seen an actual ghost sat upon the window sill. However it was always in the back of my mind that later this evening I'd have to return to the room and spend the night here alone.

I left a voice recorder on in my room to pick up any unusual sounds when the room was empty, and we quietly moved along the corridor to Room 5, John's room. We sat down in the three seats in John's room, which was spacious for a hotel room, but seemed small compared to the Duke of York Suite we'd been in for the last hour or so.

Rich asked John to close the bathroom door that he could see into from where he was sat, as he said dark bathrooms make him feel uneasy. Rich tried asking for anyone with us to make themselves known, to which there was no response. We tried asking a variety of questions across the next fifteen minutes, but each was met with silence. We

agreed that the room felt flat, and John seemed quite pleased by this saying that he will have no problems sleeping later on.

We talked over a different approach and lit a small candle in front of the mirror in John's bedroom, and another in front of the bathroom mirror. Rich sat in front of the mirror in the bedroom and John stood in front of the huge bathroom mirror. Within only a couple of minutes Rich said he felt a warm tingle across his shoulders and down his arms as if someone was hugging him from behind.

After five minutes John and I swapped places. I'd been in the bathroom for five minutes when John and Rich whispered quietly for me to come back into the bedroom.

They told me they could hear voices, and soon I could hear them too – a man and a woman talking. We remained silent, listening intently, and the voices stopped, but were replaced by a rhythmic banging and moaning. We realised the noises were coming from the next room and were most definitely not paranormal!

John set his newest item of equipment; a video camera with night vision functionality on a dressing table with most of the room in its field of view and pressed record. We left the room and crossed the landing and Rich unlocked the door to Room 11. Rich sat on his bed, John and I sat on the chairs facing the bed.

There was a wide mirror high on the wall above the bed and I saw something black move across the window behind John, blocking out the light, although it couldn't have been outside as we were on the first floor. I asked John to sit in my seat and I walked past the window. We established that the light must have been blocked out at head height with the window being so high.

Again, in a similar vein to Room 5 the room felt comfortable, it was flat, and with it being after midnight it seemed that we would be better off moving on to another room than spending more time here.

We walked past my room and to the lavish communal sitting room at the top of the first-floor staircase. As we'd expected at this late hour it was empty. We passed through the room and into a boardroom that we'd been told we could use when we checked in. It was a fairly narrow room with a long table with five seats around it – one at each end, and three down one side. John sat at one end and I sat at the other with Rich in the centre seat. We placed our voice recorders on the table and began our session. Unfortunately, twenty minutes passed by uneventfully.

We relocated to the sitting room, sitting in big comfy chairs, and again we asked aloud for some kind of indication that we weren't alone, but all of our attempts to communicate with any spirit that might be present proved fruitless. There was absolute silence, occasionally broken by the faint sound of passing traffic. It was after 1.00 a.m., and with a long day and night ahead of tomorrow we agreed to bring our investigation to an end.

We agreed to meet the following morning and wished each other a good night, however, little did we know at the time but for two of us that most certainly wasn't going to be the case.

When I entered my room I was on edge as a result of the happenings earlier: the bangs, the voices, the cold spots, and the figure that Rich saw. I walked past the eerie portraits in the living room and headed into the bedroom. I turned the television on as the silence made me feel uneasy. I climbed into the large, plush, comfortable bed

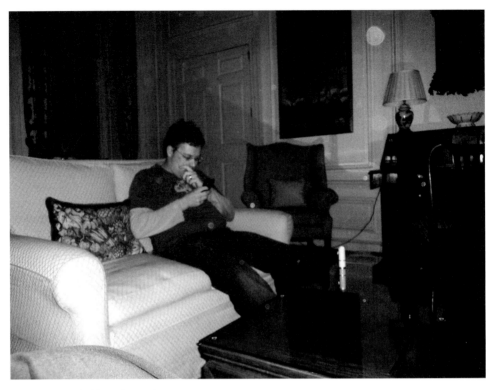

Rich surrounded by orbs in the Sitting Room.

but despite being absolutely exhausted I couldn't sleep. After watching abysmal early morning television I finally dozed off sometime after 2.00 a.m.

I was rudely awaken by a high pitched alarm, but I was still very tired as I felt like I'd only been asleep a couple of hours. A little disorientated I reached for my mobile phone. The alarm wasn't my phone, and I'd only been asleep just over an hour as it was 3.03 a.m.! So what was the noise? I got out of bed and quickly realised the noise was coming from inside the bag with my investigation equipment in. It was my EMF metre, a piece of equipment I've taken along to all of our investigations in York but rarely used. It measures electromagnetic fields which would usually be caused by a power source such as power cables, or an electric socket, but EMF can also be caused by the presence of spirit. To operate it you push a button in on the side and it shows a reading and makes a sound depending on the level of EMF. However, I wasn't pushing the button in so it shouldn't be going off at all yet it was reading a 10, the highest possible reading on the scale. As soon as I had picked it up it stopped. The next morning when I would tell the guys what had happened, I demonstrated the sound in the same spot and the reading was virtually nonexistent, so whatever was causing the reading wasn't a power supply in the room.

I woke at 9.00 a.m. after a terrible night's sleep, and I knew the others were going for breakfast, but rather than join them I decided to have a bath to try and wake myself up. After I had my bath and dressed, I sat at the window for a while watching the squirrels, rabbits and birds in the meadow outside. It was fairly sunny, but the early morning frost

glistening on the grass a sure sign that the recent Indian summer we'd been lucky enough to have, having not had a proper summer as such, was well and truly over.

At just before 11.00 a.m. John and Rich came to my room all packed and ready to leave. Before I could even ask how they'd slept, or how their breakfast had been, Rich pointed an accusing finger in my direction and asked if I'd turned his radio on. I didn't know what he meant, so he went on to tell us of what had happened after we'd gone our separate ways the night before.

I returned to my room ready for a good night's sleep, quite pleased that nothing major had happened around my bedside during our vigil earlier that night. As soon as I had unlocked the door and started to push it open I could hear a light mumbling coming from inside, accompanied by that ultra-high-pitched electronic whine you get when somebody turns a television on in another room.

'Hello?' I asked, adopting a fighting pose that I'm sure resembled Muhammad Ali at the height of his boxing career, and not a frightened Geordie at the height of his ghost-bothering career.

I turned the corner into the bedroom area and spotted the radio was glowing and soft voices were spilling from it. I cursed Rob for his practical joke, I was sure he had knocked it on as we were leaving the room an hour or so before. Switching it off I noted how difficult it was to turn the knob, it required a bit of force before it would audibly 'click' on or off. It wasn't something that could be done accidentally.

I didn't dare to look in the mirrors in the room as I got ready for bed; I tried to push the thought of Rob's dark shadow moving across them out of my mind and started to watch television.

Several hours of viewing later, I felt suitably exhausted enough to fall asleep but it was breakfast time. I met John and we headed down to one of the best breakfasts I've ever had. Pastries, cereals, cooked meats and eggs. I was offered a choice of two different types of bacon – or both. However, it was the final straw for my tiredness, so I went back to my room after the meal and (with sunshine blazing through the blinds) promptly fell asleep.

After my nap, we all met in Rob's room and I cursed him again for leaving my radio on. He is known for being a bit of a prankster, but swore blind that it had nothing to do with him. Prankster he may be, but a good liar he is not, so I opted to believe him.

I was glad the night was over but I was ecstatic we hadn't booked a second night ...

John said he'd slept soundly from the moment his head hit the pillow until his alarm woke him up in time for breakfast. He told us that after the breakfast, which he agreed was one of, if not the best, he'd ever had, he reviewed the footage from the video camera, and sadly we'd drawn a blank.

We checked out, and thanked the staff for their wonderful hospitality. They enquired as to how we'd gotten on, and we told them that despite the initial investigation being a little disappointing, other than the happenings in the Duke of York Suite, we'd experienced two impossible occurrences overnight.

We put our bags into the boot of my car, and discussed what we were going to do on our day in York leading up to another paranormal investigation that night.

CHAPTER NINE
THE COUNCIL CHAMBER OF SECRETS

York Guildhall – 28/10/11

As we drove out of the Middlethorpe Hall Hotel's car park we were still buzzing after the night we'd had. Yes we'd had long periods of inactivity but what we did experience was some of the most tangible evidence for the existence of ghosts from our York adventure thus far. We had the entire day ahead of us; it wasn't even midday yet, so I drove in the direction of a location we'd longed to return to for months – York Tyburn.

York Tyburn appeared totally different to how it had appeared when we'd investigated it earlier in the year, and had captured *the* most amazing EVP any of us had ever heard. 'Have there been some bushes removed, or trees cut back or something?' asked John quizzically, the truth was much simpler; autumn had hit York Tyburn hard, with the dense trees shedding all of their leaves. Also, it had been night time when we'd been here last, with everything appearing in different shades of black, making it tricky to distinguish, well, anything! We sat on the benches at the monument for York Tyburn and looked out across the wooded area and beyond. I pointed out the area in which we captured the definite voice of a little girl on Rich's mobile phone, and on the spur of the moment Rich suggested we try a short EVP session and see if we could make contact with her again. There was no one else within earshot so John and I agreed. This time we had five recording devices between three of us, so we pressed record on all of them and positioned them around us. As Rich attempted to communicate with the little girl, or any other spirits that may be there, I took some photographs. We recorded for ten minutes, but upon listening back to the recordings there were no voices other than ours.

We left York Tyburn and drove through a heavy traffic jam through the centre of York and finally reached the Cumbria House at just after 1.00 p.m., our accommodation for tonight where we were warmly welcomed by the owners, Tom and Elaine, who had only taken over the bed and breakfast the previous month. We were offered a cup of coffee or tea, and we had a chat about ghosts, a subject Elaine found fascinating, and even discussed the possibility of their B&B being haunted due to it being built in 1876. However, Tom said if we did see anything, as we'd be staying on the very top floor of the building, not to tell him as it terrifies him. I noticed a few days later that they'd Tweeted: '*I hope that little grey Victorian girl, who floats around the top floor landing behaves tonight!*'

We left the car at the Cumbria House and walked into the city centre. Rich checked his phone and laughed as his wife Amy had sent him a text message to say the Cumbria House had Tweeted about us: '*We've got four paranormal activity guys staying on Friday. I'm scared!*' There may have only been three of us at the moment, but Tom

was driving to York once he finished work and the team would be reunited for our penultimate ghost hunt, as tonight we would be spending the night at York Guildhall as guests of Mysteria Paranormal Events.

The city centre was extremely busy, with students, families, and tourists at every turn. We walked past the Minster and down Stonegate, passing No. 35, Haunted, the venue we so recently investigated.

John got a sandwich from the York Hog Roast and we went to the Cross Keys. It was a cold day outside so we were surprised to find that, despite the pub being fairly busy, there was an empty table in front of a roaring open fire. We took a seat and, as Rich went to the bar, I mentioned to John that there were Halloween pumpkins dotted all around the pub. When Rich got back from the bar he told us that the Halloween theme stretched to the ales they had on tap, which included Ripper, Witch's Brew and Ghost Ale. We sat back, chatting about all manner of things as we watched the busy world pass us by for the next few hours.

We left the Cross Keys around 6.00 p.m. and it was very cold. On our way to the Cumbria House we passed York Minster which looked staggering all lit up against the clear night's sky.

We arrived back at the Cumbria House half an hour later and rang the doorbell. Elaine answered and looked delighted to see us again. We had grabbed our bags from the boot and she took us up to the top floor and showed us into a nice family room.

We changed into suitable clothing for the long, cold night that lay ahead, and took it easy while we waited for Tom who we expected to arrive at around 7.30 p.m.

Tom wouldn't be Tom if he turned up on time, so at 8.00 p.m. when he did show up he had to very quickly change out of the suit he'd had on for work. We had to be at the Guildhall for 8.30 p.m. and so had to leave straight away. We walked quickly as we didn't want to be late, and as we neared the city centre the streets were flooded with vampires, devils, zombies and all manner of other otherworldly creatures, and we'd not even begun our investigation. However, this was nothing supernatural; it was Friday night drinkers dressed up for Halloween.

Despite being a few minutes late we were the first there. I hung back to take a few photographs so Tom approached the lady waiting to greet us and he said 'Hi we're Rob Kirkup and his Ghost Squad'. The lady, who introduced herself as Rachel Hayward, welcomed us and ticked our names off her list. She told us they were expecting a further twelve people before the investigation would begin at 9.00 p.m.

As we waited outside of the Guildhall, Tom asked if I knew any of the ghostly happenings said to have been reported in the majestic old building. The truth was that, in a similar vein to last night's investigation of Middlethorpe Hall Hotel, I knew very little of the activity, but earlier in the year when I contacted York City Council about York Tyburn, the helpful lady I spoke to suggested that it might be worth checking out the Guildhall as it had been particularly active in the last couple of years. It was on the back of this that I contacted Mysteria Paranormal Events who have exclusivity on investigations here, and I was told that York Guildhall has delivered some amazing results on previous investigations. One particularly odd occurrence that I had been told of was when the management of the building found children's footprints on top of a seven-foot-tall grandfather clock.

The team outside of the York Guildhall.

Located behind the Mansion House, in which the Lord Mayors of York live during their term in office, is York Guildhall. Work began on the Guildhall in the accounting year 1446–47 upon the site of an earlier common hall first documented in a charter in 1256. It served as a meeting place for the 'Guild of St Christopher and St George', and the first council meeting was held there in May of 1459 even though the building was far from complete.

There is a plaque within the building to commemorate Richard III's social visit to York Guildhall in 1483. He was a popular figure in York and was a frequent visitor to the city, having grown up in the area.

The Guildhall was primarily used for meetings, but it had other uses. It was an occasional Court of Justice, and is most famous for the trial of Margaret Clitherow. She was on trial in 1586 for practising Catholicism and harbouring Roman Catholic priests. She was put to death for refusing to accept the jurisdiction of the court, and she would die in a particularly grisly manner. She was stripped naked and laid out with a sharp rock the size of a man's fist beneath her. She had a heavy wooden door placed on top of her and slowly loaded with large, heavy rocks until the weight caused the rock beneath her spine to snap. It took Margaret fifteen minutes to die.

Her lifeless body was left for six hours before the immense weight was removed. Her hand was removed and the relic is housed at Bar Convent. In 1970 she was canonised by Pope Paul VI.

The night of 29 April 1942 was a low point in the city's recent history when the lives of over seventy people were lost in the Baedeker raids. As well as this tragic loss of life there was severe damage caused to many buildings in the city including York Guildhall, which ironically had been in the process of restoration at the time. It was eighteen years before the stone shell of the building was restored, complete with a modern stained glass window, and reopened in 1960 by the Queen Mother. Representatives of Munster, York's German twin town, were present as that city had contributed to the restoration costs.

To this day, council meetings are still held at York Guildhall in the magnificent Victorian Council Chamber that was designed by E. G. Mawbey, the city surveyor, and completed in 1891.

At 9.00 p.m. precisely we were invited inside of York Guildhall, and the four of us had been joined by a brother and sister who'd turned up shortly after we had, and a party of eight who had booked onto the investigation as a birthday 'treat' for one of their number. We were led to a nice warm staff room with a large table and coffee and tea making facilities.

Our host for this evening was Ramon, and he introduced himself and the rest of the Mysteria team to us: Rachel, the medium for tonight, who we'd already met, and Richard who works at York Guildhall.

Before the ghost hunt we were going to be taken on a ghost walk of York by Rachel, who had earlier told us that she runs a weekly ghost walk every Thursday and is studying for a PhD in a subject relating to the paranormal at the University of York. I put my woolly hat on and grabbed my camera and trusty Olympus voice recorder, leaving my bag behind. The ghost walk was a enjoyable experience, a strong mixture of some of the famous locations, such as the Treasurer's House and 5 College Street, and some of the lesser-known locations such as the White Swan Inn and the Guy Fawkes Inn – the latter being particularly apt with the 5 November being a little over a week away.

An hour later we were back in the warmth of the staff room at York Guildhall for a much needed sit down, toilet break and a hot drink. We had been joined during the walk by a young couple from Manchester who had been running late, and this completed the line-up for tonight; sixteen investigators, Richard's expert knowledge of the building, and the guidance and medium skills of Rachel and Ramon.

Ramon, sitting at the head of the table, took a sip from his drink and asked if anyone had ever been involved in a paranormal investigation before. I looked around at the

Rachel (right) briefs us on what to expect on our ghost walk of York.

new faces around the table; no one put their hand up except for the four of us. Ramon knew of our year-long adventure which had taken us to some of York's most haunted venues, and asked if we'd like to share our experiences with the group. His gesture had been directed towards me more so that the other guys. I looked at Tom, John and Rich and each bore an expression that said 'go on then, talk!' I turned to our teammates for tonight and introduced myself and explained this book, and some of the locations that we'd investigated so far. They all seemed genuinely interested and had lots of questions for us around how we got into ghost hunting in the first place, what we'd encountered so far, and if we had expectations for tonight. The truth was that I had no expectations whatsoever, but I was excited to find out what would happen when our investigation got underway.

Ramon wanted to discuss the important topic of health and safety. It was imperative that everyone have their own torch as some of the areas we'd be going into would be very dark. He was also keen to stress that there would be the opportunity to take photographs, but flash photography can delay eyes becoming accustomed to the darkness, and this would also be the case if someone was to have a torch shone towards them, so torches should be kept pointing towards the ground. He added that after having a discussion with Rachel, for the majority of the evening ahead we would all be staying together as one group; this last point concerned me slightly as there were nineteen of us in total, and it would be near to impossible to differentiate between genuine paranormal activity, or a sound or the feeling of being touched coming from another investigator.

Rachel led a psychic workshop which she said might help when our investigation began. She explained that everyone has the ability; it's a matter of training and harnessing it correctly. We all sat with our eyes closed, breathing deeply as Rachel talked, painting pictures with her words. When she asked us to open our eyes, I certainly felt more relaxed, but had I harnessed my psychic potential? It was time to find out.

In order to put our newfound powers to the test, we swapped an item of ours, something dear to us, with someone else in the room we didn't know. I gave a guy, who I hope won't mind me saying, looked a bit like Simon Pegg, my wedding ring, and he gave me his car keys. We sat quietly with our eyes closed, holding onto the object and Rachel talked quietly to help us focus. We had to think about whatever came into our mind when we thought about that object. I couldn't think of much, but once we'd opened our eyes Rachel wanted us to go around the table and say what we thought of and I was first. I said 'a green car?' but the guy shook his head and said, almost apologetically, 'my car is black mate'. Tom and John also drew a blank with their partners, but when it came to Rich's turn he'd obviously unlocked some powerful mental ability that had lay dormant within him until now, as he reeled off a huge long list of things that would put Mystic Meg to shame 'I'm seeing a holiday somewhere tropical, a big bird, birthday cards, perhaps some kind of party ...' To all of these the lady was shaking her head. His list continued, and by now seemed like some kind of psychic version of the Generation Game. He eventually said 'a white Vauxhall Corsa' and she stopped him immediately and said that she'd quite like a white Corsa. This was chalked up as a success.

Rich's partner came up with nothing, hardly surprising considering the item 'dear to his heart' that he had handed over was his glow-in-the-dark torch that he'd only

bought the day before from the Metro Centre for the princely sum of £1. There were a few genuine successes though, which definitely gave me food for thought as to how productive a longer workshop could be.

It was now the time we'd all been waiting for; our ghost hunt was finally underway. In a similar manner to what we'd usually do, Ramon said we'd begin with a walkthrough of the building room by room; an opportunity to take some photographs and get a feel for the building.

Out into the main hall, Rachel told us that she'd been on a few investigations now and always got the image of dancing here although she couldn't explain when or why. Rich whispered to me, perhaps on the back of our psychic workshop, that he has a very strong feeling that soldiers from the war were dancing and celebrating in the room.

Someone spoke up 'I feel cold, my feet are very cold'. Ramon added in agreement 'yes it feels like the cold is coming up from the floor', there was lots of nodding and a chorus of people agreeing 'yes it's very cold'. I felt cold but until now I hadn't considered it being anything paranormal. We'd been sat in a nice cosy heated room drinking hot tea and coffee, and now we were out in a big draughty hall on a freezing cold night. There was no time to dwell on it though as we were on the move.

The next room was an impressive meeting room with rich wood-panelled walls, a long table with fourteen seats around it, and a stunning view of the River Ouse. The first thing I noticed upon walking in was the smell, which I heard a few other people comment on. It was a burning smell, and took me back to standing around bonfires on 5 November, the smell of the burning wood, and the distinctive scent of the spent fireworks. Ramon said, 'Can everyone else smell burning?' and every single one of the nineteen people in the room agreed. Someone asked Richard, our Guildhall expert, if there had ever been a fire in the room, and he said that the building had suffered extensive damage over the years but there'd been no fire in the room that he was aware of.

The Main Hall.

We stood quietly for a few moments and Rich complained quietly of a terrible headache. Ramon made everyone jump as he suddenly spoke up, pointing to us, the light through the window casting his eerie shadow across the wall. 'How do you four in the corner feel?' Rich replied that he had a headache. Ramon explained why he had been drawn to the corner we were stood in: 'There is a mirror on the wall behind you, I saw a face in that mirror looking at each of you in turn, and it had an evil grimace on its grotesque face.' We all turned around and there most definitely was a mirror behind us, but none of us had seen or felt anything.

Someone from group celebrating a birthday said they felt the darkness in the doorway behind Rachel was getting darker, and forming the shape of a person behind her. A few other people were visibly and audibly shocked by this, as they too looked and could see the same thing.

We moved into the next room, which was even more impressive than the last. Again it had wood panelling and a large wooden table in the centre. Around it were two circular rows of wooden seats with leather padding. Towards the back of the room were three rows of wooden benches, and the only noise was the loud ticking of a clock above these benches. Richard told us that this was the Council Chamber, and council meetings have taken place in this very room for over 500 years. The first thing we all picked up on was the same burning smell from the previous room, it seemed likely that it was something to do with the polish they use on the wood. The room was fairly generously lit from the huge windows.

Rachel said she was picking up on a much darker vibe in this room to the previous rooms; she said she felt threatened. Rich was stood to my right and spoke up in agreement 'I feel watched, actually I feel danger', and Rachel nodded in agreement. A few moments later Rich told me quietly that someone had just poked him in the back of his leg. I told him to speak up as Ramon had earlier told us that if we feel something to speak up straight away, so he did. 'Someone's just poked me in the back of my knee pit' he said loudly to everyone. Rachel said there was definitely something in the room with us, and it 'didn't feel right', it felt powerful and intense. At that moment, the girls from the birthday party group all let out a loud simultaneous scream; they'd heard a loud bang in the seats to the back of the room.

Tom joined in with the psychic detective work, asking 'Has anyone fallen down here in recent years?' Ramon responded before Richard could speak and said that with the building being over 500 years old it's almost inconceivable to think people won't have fallen down, but nothing significant.

John and Rich split off from the main group into a dark corner that they'd both been drawn too, and a couple of other people had commented that they'd felt 'something' was watching us from. Rich and John immediately walked into an icy cold spot which didn't seem to be from a draught from the window. Rachel joined Rich and John and agreed there was definitely a presence with us. All the while this was happening there were more noises coming from the back of the room. There was so much activity going on all around us that it seemed such a shame that we had to move on, although it was agreed we would definitely have to return to the Council Chamber later to see what else it would have in store for us.

Just off the council chamber was an antechamber with a table in the centre and a couple of large windows overlooking the River, providing plenty of light into the

relatively small room. After five minutes of inactivity with both Ramon and Rachel saying that they weren't picking up on anything, we moved on again.

We headed upstairs and were led to a long, narrow corridor with a huge painting leaning against one wall. It was really warm, uncomfortably warm. A voice from out of the darkness said 'I am thirsty'. Rich spoke up and said 'I'm so thirsty that my mouth is stuck together!' There was then a loud bang from back along the corridor close to the door we had came through; however, Tom and I were at the back of the group and there was no one behind us. Richard told us that the only people in the building were the people on the ghost hunt, there were no members of staff, or cleaners working at this hour.

We went downstairs, all the way down to the basement. It was another warm room, mainly used for storage, and no sooner had we all reached the bottom of the stairs than there was a loud bang from behind a partition wall. Ramon asked if anyone fancied standing over there alone, there were a few responses of 'no chance', but John, always willing to investigate further, shrugged his shoulders and said 'I'll do it'. He coolly walked off into the darkness. There were several loud bangs from all over the room before we went through a double door and into the kitchen.

In the kitchen Rachel said she was seeing the very vivid image of a hooded figure, similar to a monk. She said she'd never sensed this spirit before at Guildhall and asked Richard if this would make any sense given the history of the building. Richard took a moment, and then said, as if surprised, 'yes, it does, it's not very well known but the site of this building was once a Friary'.

The final location of our walkabout meant going outside, and by now the temperature was nudging zero degrees Celsius so it was time to wrap up warm. We were led to a small door, and Rachel told us that beyond the door was a tunnel beneath Guildhall which led down to the river. We entered one by one, and the darkness was absolute once inside. It was cold, but dry, and we didn't see any of the rats that Richard had warned us were prevalent in the tunnel as they come up from the riverbank. We weren't there too long, but long enough for one female member of our party to let out a blood curdling scream because she said she felt fingers walking up her back. She turned around quickly but she was stood with her back close to the wall and no one was behind her. Another member of the large birthday group gasped loudly, covering their mouth in horror. One of their friends asked them why, but they continued to stare. Their friend begged them to tell them what was wrong. They finally spoke and said they'd been looking down the tunnel towards the open end down near the river and they saw a face look around the wall at the bottom of the tunnel, then vanish back into the shadows.

We returned to the base room for a short break. I had a drink and looked around at the other members of the party; a few seemed very uneasy having been around the building after dark, the laughing and joking of which there had been plenty earlier in the evening had all but stopped and there were several worried frowns. I think it had quickly hit home that this was very real, and perhaps those who had booked onto this event believing it would be a bit of fun had a long night ahead of them.

Ramon had earlier asked if there were any sceptics in the room, to which three people put their hands up, one of which was our very own Tom. Ramon took the opportunity on our break to sit down with Tom and enquire as to his scepticism, and what would convince him there are such things as ghosts.

The entrance to the tunnel.

It was midnight and it was time to begin our investigation properly. As one group we headed back to the Council Chamber which had seemed so promising earlier. We spread ourselves around the outside of the room. Ramon asked if anyone would sit in the seats at the back where there'd been definite bangs heard earlier. There was initial reluctance from the other members of the group so Ramon looked to the four of us, the more experienced members of the group. I spoke up and said I didn't mind. I climbed over a low wooden barrier and took a seat in the back row. I immediately thought I saw figures move in front of me, but it was the brother and sister who were part of the hunt. They'd not said a word, but came to join me, sitting right next to me.

Everyone stood, or sat, silently for a few minutes. The only sounds I could hear were the whistling of the wind outside and the pounding heartbeats of the two first-time investigators sat next to me.

Ramon suggested we all gather around the central table and ask the spirits, that both he and Rachel were convinced were with us, to use our energies to 'come forward'. This we did, and despite a few clicks and bangs coming from elsewhere in the room it seemed fairly calm.

The room had appeared so active earlier that we all agreed it would make sense to remain patient, but perhaps splitting into two groups, with one staying here and one moving into the antechamber next door, might be a more productive move. Rachel was keen to stay in the Council Chamber so Ramon asked for eight volunteers, four boys and four girls, to go with him to the next room. Rich, Tom, John and I had a quick chat and decided to split up, Rich and John staying in the Council Chamber and Tom and I following Ramon.

In the antechamber Ramon asked us to sit around the table, boy-girl-boy-girl, as he said he believed this helped the energy to flow. I'd never heard of this theory before but was happy to go along with it. He asked us to join hands to help the energy flow while he asked out for the spirits with us to let us know and to come into the circle. Several minutes passed, and the only thing I'd heard was the sound of Rich loudly talking in

the Council Chamber. He suggested the girl sat next to me, a young lady called Jade from the birthday party group, to swap places with the girl opposite as that might help. It didn't.

Ten minutes later we rejoined the other group in the Council Chamber and they'd had far more of a result than us with some truly amazing happenings; Rich had been the main person asking out with a little help from John, as is usually the case on our own investigations, and they'd successfully made contact with someone who'd come to the Guildhall to repent their sins. This was backed up with bangs and knocks, and even the sound of chains or keys jangling. Things became so intense that one woman from the party of eight celebrating a birthday had to leave, not only the room but the building, and didn't return. For her the investigation was over.

Despite the activity in the Council Chamber the night was slipping away and we had to move on as we had many other rooms investigate.

We descended the staircase to the basement and into the kitchen. The eighteen remaining members of our team stood in a large circle, boy-girl, and held hands. Ramon began asking aloud but for almost ten minutes we had no response whatsoever. Rachel suggested Rich or John ask out as they had in the previous room with great success. Rich turned to his left and said 'Do you want to ask out John?' but a deep unfamiliar voice came out of the darkness and said in response 'I'm not John'. Rich had thought John was nearby, but John was actually opposite Rich in the circle.

Rich spoke aloud and we immediately heard a few bangs come from a dark corner where no one was standing. A woman standing hand in hand with Rich complained of stabbing pains in her stomach and had to leave the room. She returned a few minutes later but didn't feel comfortable in the room. We then heard voices talking outside in the main basement area, although everyone in the building was accounted for and was stood inside the room.

Ramon asked for a volunteer to go into the centre of the circle, so we could ask the spirits with us to use our collective energies and affect the person in the centre somehow. Tom bravely said he would. However, any requests for Tom to be touched, spoken to, or pushed unfortunately failed and, with it fast approaching 2.45 a.m., it was time to move to the next location which would prove to be our final area – the tunnel.

The tunnel seemed almost darker now, if that was possible. We stood in a circle halfway down the steep slope, and before we could even begin to attempt to make contact with the spirits lurking within Rachel jumped, making everyone else jump. 'Did someone just touch my arse?' Of course no one had, for one we were spaced fairly far apart and there was no one behind her. She apologised for her outburst but described what had happened being similar to someone running up behind her and kicking her hard up the backside.

Ramon saw the value in a willing volunteer standing a little further down the tunnel, behind where Rachel was stood; he added 'perhaps one of you four guys might want to?' I said I would, and moved a couple of metres further down the tunnel as the others moved closer together to fill the gap in the circle left by me. After only a few minutes I heard noises right behind me, a shuffling sound. I turned around expecting to see a rat, but upon scanning the area with my torch I saw nothing at all.

With Rich leading the session, asking for signs and responses to questions, it didn't take long for the tunnel to become incredibly active with sounds all around us, stones being thrown, and several people saying they'd been touched or had their clothes tugged. It was almost inconceivable that we could be alone; there was most definitely something with us in the darkness.

As if that wasn't impressive enough we saw a light at the end of the tunnel that we'd entered via, the entrance which was now firmly closed behind us and there simply couldn't be any light coming in. The bright white light was moving back and forth, and we all looked on, astonished. This had us all beaten although a couple of people tried to rationalise – perhaps a car had come into the car park to turn around? Richard explained he'd locked the gate earlier in the evening and cars couldn't enter. There were two cars parked outside, but the owners of both those cars were in the tunnel with us. All of a sudden a voice called down the tunnel from where the light was. 'Hello?' Several of the ladies in our group screamed in unison, whilst almost everyone else involuntarily swore. Disappointingly it turned out to be some members of a different Mysteria Paranormal Event which had been at Haunted. They'd decided to pay us an unplanned visit upon their investigation finishing.

They were led by Annette, a medium of many years, who went on to tell us what she could sense in the tunnel. However, before she could even begin one of the ladies from the large birthday party let out a scream and began to cry, before anyone could ask what had happened she was led out of the tunnel by a friend.

The dark, creepy tunnel running down to the River Ouse.

Annette described twenty workmen walking down the tunnel on their way to work, perhaps to catch a barge from the river. Richard said this could well be the case as boats along the river would have been a popular mode of transport. Ramon asked if they had heavy boots as he couldn't move his feet as if he was wearing really heavy boots, Annette nodded and said 'yeah very heavy'. She said they were all residual spirits who passed by us, unaware of our existence. There was one exception, a workman called Max, who had hung back slightly from the rest of the group as he could see us all. Someone suggested we walk to the bottom of the tunnel, Annette agreed this was a good idea. Some of us heard a bang from the very bottom of the tunnel, beyond where we were stood. John went to investigate, but found nothing.

Annette told us that Max had stopped to look at us a one of our party, a young woman with blonde hair stood near the wall. A voice said 'that's me', it was Leanne, a young lady who'd come up from Manchester with her boyfriend. Annette said she reminded Max of his own sister, she added that his spirit was fading away now as were the other workmen.

It was almost 4.00 a.m. so we headed back to base one last time. We were all exhausted, but we'd had a very eventful evening. Richard wanted to tell us some of the things that had happened at his place of work. He said the Council Chamber is well known as being particularly active, and on the last investigation in the building someone actually collapsed in the room. I found this particularly interesting given the question Tom had posed much earlier as to whether anyone had fallen there.

He also said everyone who worked there feared the basement, and people who do need to go down there often won't look behind them as there's a constant feeling of being watched.

Ramon and Rachel thanked us all for joining Mysteria Paranormal Events for the evening and hoped we'd all had a memorable time. We all gave them a round of applause and it was the perfect way to round off what had been a fascinating night.

We said our thanks and goodbyes and the four of us left at 4.15 a.m. for the thirty-minute walk back to the Cumbria House. The streets of York were almost deserted and it was so was cold that by the time we got into our beds at close to 5.00 a.m. we were all wide awake. We chatted quietly about our highlights from the evening, until one by one people started to doze off.

I'm not sure what time I fell asleep but John's alarm woke us all up at 9.00 a.m., something none of us welcomed having only had a few hours sleep. We were all far too tired to go for breakfast, so showered and packed up our belongings. We headed downstairs with our bags at 10.00 a.m. and thanked Tom and Elaine for their hospitality. They asked how our night at York Guildhall had gone so we chatted for a while, Tom asking if we'd experienced anything odd in the room on the top floor, but we said that if anything had happened we'd all have slept through it. We said goodbye, but it wouldn't be long before we'd be back, as we'd be staying here again for our final ghost hunt in under a week.

Tom drove away in his car, waving to us as Rich and John climbed into my car for our drive home.

CHAPTER TEN

THE LOCK-IN

The Golden Fleece – 03/11/11

Almost thirteen months since we'd first ventured south to investigate the National Railway Museum we were taking the long drive to York one last time to see what England's most haunted pub – The Golden Fleece – would have in store for us. In the week leading up to this night there'd been a lot of excitement – summed up best by the email Rich sent out to the rest of us which simply said '*I can't wait, I have a feeling we're going to SEE something!*' However, our unanimous excitement and anticipation was tinged with the sadness of knowing that this would be the last time we'd tackling the unknown for a while, perhaps even the last time we'd ever be together as a team.

Once again, I was the designated driver and, after picking up Rich, John, and finally Tom, we were on our way. A local radio station's jingle for the 7.00 p.m. news came through the speakers of my Ford Focus as we past the Washington Services on the A1 southbound. I turned the radio down slightly and asked their thoughts on the investigation only a few hours away. Despite a long day at work everyone seemed to spring to life when the topic of the Golden Fleece was raised, this was a venue so synonymous with haunted York we knew we *had* to experience if our York adventure was to be complete.

We arrived at Cumbria House at around 8.30 p.m., with the lovely Elaine greeting us once more, and showed us to our room; the family room on the top floor we'd stayed in a little under a week earlier.

We had an hour to kill before we had to leave for the Golden Fleece so we changed out of our smart work clothes and into our ghostbusting clothes and took it easy. We'd all had a long day at work and we had a long night ahead of us, so we deserved this little bit of downtime. The others were catching up on text messages and browsing the internet on their phones, so I made myself a nice cup of coffee using the excellent coffee and tea making facilities provided, and lay down to read the *Fortean Times* magazine I'd brought with me.

'Do you really think we'll actually see a ghost tonight Rich?' Tom asked, sitting up to register Rich's reaction to his question. 'Well I don't see why not,' Rich responded thoughtfully. 'From what I've read quite a lot of the activity reported are actual sightings of apparitions, aren't they Rob?' I put my magazine down and gave the others a potted history of the Golden Fleece, and the ghosts that lie in wait within.

The Golden Fleece is one of the oldest coaching inns in York and is mentioned as early as 1503 in the city's archives. It is believed it was named for the fleeces and wools

traded by the Merchant Adventurers who regularly drank at the inn, when taking a break from trading, and caring for the sick and the poor at the nearby Merchant Adventurers Hall.

After the English Civil War there was an acute shortage of currency and siege money was produced as an alternative with the Golden Fleece having its very own token, which had the value of a halfpenny and included the name of the then landlord Richard Booth, along with the date 1668.

By 1701 the Fleece was owned by John Peckett, the Lord Mayor of York, and the current function room and one of the bedrooms is named for his wife, Lady Alice Peckett.

Despite the numerous redesigns the building has been through over the last 500 years, structurally it's very much the same as it was all those years ago, with the exception of the entrance and the top bar which were built more recently when the building was extended out into the street. The building has no foundations and is built atop stilts, giving the Golden Fleece the quirky sloping floors and staircases that really give the place the unique charm that makes it so popular with the locals.

The Golden Fleece is famed for the ghosts that haunt every nook and cranny of the ancient inn, with some books and websites claiming that as many as fifteen individual spirits are resident, although the Golden Fleece's website states that it's more likely to be between five and seven. The most famous of these is the elderly phantom of Lady Alice Peckett who has been seen regularly for almost three centuries wandering the passageways and silently gliding through two of the bedrooms; The Lady Peckett Room and the Shambles Room, no doubt rooms which she knew so well in life.

Another well-known phantom is that of a Canadian airman who died in 1945 by falling from the window of the room which is now the Minster Suite. Despite being a fairly recent passing the details surrounding his death are unclear with some sources stating that he committed suicide, and others saying he fell accidentally after drinking heavily. The name of the ghostly airman varies as well, but is most commonly named as Geoff Monroe. A number of shaken visitors across the years have reported waking to see a man in Second World War pilot attire stood at the foot of the bed looking directly at them. Others have seen a man fitting the same description at the window looking down onto the streets of York three stories below.

In St Catherine's Room there have been infrequent sightings of a lady at the window who appears to be in her mid- to late twenties and dresses completely in black. Much more regularly reported are the 'invisible' phenomena, with some guests being overcome by an inexplicable, chilling sensation of being watched, whereas others have woken in the night to feel a great weight pressing down upon them, stopping them from moving as well as preventing them from screaming for help.

The Merchants Bar, which is the back bar, is home to two spectres. One Eyed Jack wears a long red coat and wig, and carries a flintlock pistol. He paces back and forth, as though deeply troubled. Mediums have claimed to have made contact with 'Jack', and it appears he lost his life within the Golden Fleece in the seventeenth century, but the manner of his death is unknown. The second phantom is known as the 'grumpy old man', and witnesses have described seeing an elderly man crouched in a dark alcove watching people go about their business.

The newer top bar, named the Shambles Bar, is said to house a further two spirits; a young boy aged around seven or eight dressed in tatty Victorian clothing. It is written that he was the son of the owners of the Golden Fleece and used to love running out to meet the delivery cart, but one day his excitement turned to horror as he was trampled to death by one of the horses that pulled the cart. The other ghost is that of an elderly man who is dressed in much finer clothes from the Victorian era and appears to be unconnected to the young boy.

The Cellar, which sadly we wouldn't have access to on our investigation, was used to store the bodies of executed criminals until their families came to claim them. Phantom Roman soldiers have been seen in the cellar by terrified members of staff who've dared to go down to the Cellar alone. Inexplicable bangs and the sound of barrels being moved around have been heard when the Cellar has been empty.

So Rich was most certainly correct when he said that there are many, many reports of full spectral apparitions being seen. However, in addition to these sightings there are countless other ghostly happenings including doors slamming on their own, bedclothes being pulled off while guests have been sleeping, and cold spots. The Golden Fleece's reputation for being not only York's most haunted public house, but the most haunted in the country is undoubtedly deserved.

9.30 p.m. came around all too quickly and the time had come for us to face the Golden Fleece. We had a thirty-minute walk from the Cumbria House and the weather was mercifully mild for the time of year. We were in high spirits as we walked and talked, stopping off at a corner shop named Goldmine as we passed so we could pick up some snacks and drinks to keep us going throughout our investigation.

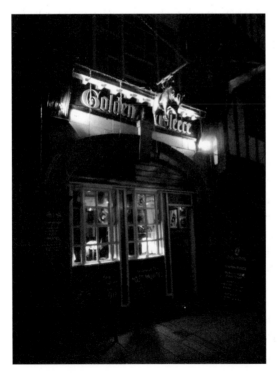

The Golden Fleece.

We heard the Golden Fleece before we saw it; when we entered just before 10.00 p.m. the place was bustling and the atmosphere was brilliant. It was an Acoustic Night in the top bar where anyone can come along and pick up a guitar and play. Everyone was singing along and having a great time. We passed through here and down the narrow, sloping passageway to the back bar which had a real buzz about the place too; it was really rowdy, and seemed to have mainly students in. We'd been told to ask for Guy when we arrived, so Rich approached the bar and asked the friendly barmaid if Guy was around. She popped into a back room behind the bar, and came back a minute or two later and said he'd be a few minutes. As we waited she asked if it was anything she could help with. Rich explained that we were the ghost hunters, and as he spoke she looked increasingly confused. She explained that the lights had gone on in the Lady Peckett Function Room a little earlier, so she assumed we'd already arrived as no one has been in there all night. As she told us this a man emerged from the room behind the bar and introduced himself to us as Guy.

He led us up a short crooked staircase and unlocked the door to the function room. He politely held the door for us and we entered. As I put my backpack on a chair around a huge dining table, I took a moment to take in the room; the dining table was covered in a deep red velvet tablecloth, and there were fourteen matching chairs around it. In the far corner of the room was a bar complete with lagers and beers on tap, and optics with a variety of spirits. Next to the bar was a large fireplace, with a grand fireplace surround. The mantelpiece had candles and a crucifix atop it. There was a piano with skulls, bones and cobwebs on top of it. As we took of our coats Guy explained this is traditionally used as the base for investigations, so suggested we might want to follow suit and use this as our base, the four of us looked at each other and without saying a word we were all in agreement that this would be an ideal base.

Guy explained that the bars would both close at midnight, after which they'd be all ours. In the meantime we had this room and the bedrooms to explore. We followed Guy out of the function room and as we walked back down the staircase Rich turned to John, Tom and I and said 'watch out, there's a dodgy step there'. Guy turned around and corrected Rich, 'they're all dodgy, with the building having no foundations there's not a single staircase, doorway, or window that's straight!'

There are four bedrooms, and we'd have sole access to the St Catherine Room, the Shambles Room, and the Minster Suite. The fourth bedroom, The Lady Peckett Room, was being renovated, and unfortunately would be out of bounds for safety reasons. As we climbed up the staircase to the first room John asked if Guy had experienced anything paranormal in the pub. Without breaking stride he said that he hadn't, but most of the staff had, and he's heard first hand some truly spine-chilling accounts which he'd be more than happy to tell us. Despite this he added that he doesn't believe in ghosts, joking that as a result the large heavy golden sheep from above the entrance to the pub will probably fall on his head.

The first room we came to was the St Catherine Room. This is the smallest of the bedrooms but was still a good size with three single beds. He pointed out the room which is now the bathroom was a hidden room for many years, and once discovered was converted into the bathroom. Guests have reported being awoken in the dead of night by the sound of children crying. There have also been a couple of claims over the years of people hearing the sound of musket fire from within the room.

The Shambles Room was next, and as Guy unlocked the door he told us that by far the most common occurrence in this room is people being awoken by the sound of furniture being moved around elsewhere in the room. He continued, 'Although I don't believe in ghosts there was one case recently, it was only three weeks ago, which really disturbed me. A couple were staying in this room and the woman woke in the middle of the night to see her husband sat bolt upright, wide awake, eyes bulging, and he was staring at the fireplace at the foot of the four-poster bed. She asked him why he was awake and what he was looking at. When he didn't answer she began to panic, begging him to tell her what was wrong, asking him over and over again. He didn't answer, he just continued to stare, completely transfixed by something. She reached out to touch him, and the moment she did he vanished before her eyes, only for her to then see him lying in bed next to her sound asleep.'

The Minster Suite, named for the view of York Minster from the window which the airman fell from during the Second World War. Guy told us that a little girl is said to haunt the bathroom. She is often seen in the mirror, and she is known to throw things around. Also, on a recent investigation someone was hit by the bathroom door which slammed shut inexplicably.

We thanked Guy for taking the time to show us around and recount such brilliant tales to us, virtually all of which I'd never before came across online, or in any of my books on the subject of York. Before Guy returned to his work, Rich took the opportunity to ask him about ghostly goings-on in the bars. Guy was only too happy to oblige and told us that with the top bar being a much newer part of the building, previous ghost hunters have found it to be one of the least active areas of the building. However, that's not to say it isn't worth spending some time in the top bar, as one of the most amazing, and most corroborated sightings in the last decade was in the top bar. Back in 2002 a group of ghost hunters sitting in the bar watched on in disbelief as an elderly gentleman dressed in upper class Victorian clothes walked through a wall and across the bar, they watched on in horror as the phantom stopped and turned to look straight at them, he then carried on walking and disappeared through another wall. One of the most common happenings in the top bar is things being thrown around, such as glasses being thrown from the bar or from shelves.

Staff in the bottom bar after hours, when the building is silent as the grave, often hear voices from the function room, when it's known to be empty. Footsteps have also been heard running across the room. Guy added that he himself has heard this, he heard men having a conversation when the room was completely empty and in darkness. Patrons and staff members have seen glasses and bottles floating in the air in the bottom bar before crashing to the ground in an explosion of glass and liquid. There are many, many bizarre cold spots in the room too.

With that Guy left us to begin our investigation. Before he left he told us that he would be working until midnight if we needed anything, but after the bar closed the landlady, Steph, would be around if we needed anything.

I checked the time; it was 10.23 p.m. so we headed back to base to plan out the next couple of hours. We had a drink and a bite to eat as we excitedly discussed our thoughts about how best to tackle the rooms Guy had given us access to.

Guy had told us of talking, banging and footsteps coming from the function room while it was empty, so when John suggested we begin our investigation here, Rich, Tom

and I agreed it made sense. We spread ourselves out around the table. We could hear a lot of noise from the top bar, so we'd have to remain focussed to establish what was occurring inside the room with us and what was outside in the bar.

John was sat closest to the light switch, and when he switched them off, it was the first time this evening we were in darkness, while my eyes were attempting to adapt to the darkness the only light I could see in the room was the blinking red LED of my Olympus digital voice recorder. The four of us sat in silence, until that silence was broken by Tom passing comment that he felt sad, really sad to the point where he said he could almost well up and cry, yet try as he might be couldn't explain why. Almost as soon as Tom had finished talking Rich spoke up and told us that he'd felt a shiver go up his spine, as if someone was walking over his grave.

Only a few minutes later I felt a cold breeze blow past me, and then come back past me, there was cold air moving all around me. I remained in my seat and John came and checked the window behind me and the fireplace to my left for draughts and confirmed my suspicions that the draught wasn't coming from either of them. Tom said that he'd already been drawn to the dark corner to my right, next to a door leading out to the top bar; he explained that he felt there was something dark and malevolent watching us. I was surprised to hear Tom say this, especially given his status as steadfast sceptic.

The activity in the room with us was non-stop. No sooner had we finished investigating the cold breeze around me than Rich said he heard a loud noise behind him that he described as 'the wallpaper crawling'. As he told this to us, he said that he suddenly felt icy cold down his left-hand side.

After such early promise whatever had been with us in that room appeared to move on as fifteen minutes passed with the only noise coming from the bar, which was getting louder by the minute. We made a decision to move on and carry out some vigils in the rooms on the higher floors away where we hoped it'd be quieter.

I suggested that we split up into two teams to cover more of the building. Everyone was happy with this so Tom and I headed to the Shambles Room, and Rich and John went to the floor above and the Minster Suite. We agreed to meet fifteen minutes later and if one of the rooms had produced results then we'd spend some additional time in that room.

Tom and I entered the Shambles Room and sat down in the bedroom. Tom sat on a large wooden box and I sat on a chair next to a large fireplace at the foot of the bed. After a couple of minutes I looked over to Tom and he seemed distracted, I asked him what was wrong, and turned to me and said he could see a figure in his peripheral vision, but whenever he looked straight on he couldn't see anything. Before I could respond we both looked skyward when there were two extremely loud bangs from the room above us – the Minster Suite that the Rich and John were in. When Tom looked to where the figure had been standing, it had vanished.

Fifteen minutes passed by fairly uneventfully but we were optimistic that the others would have more success than we had. We made our way up to the Minster Suite and when we pushed the door they'd not been expecting us and before we could tell them it was us, Rich shouted 'What the HELL was that?' as John swore very loudly. After they'd gotten over the shock we'd unintentionally given them they told us that they'd experienced a lot of activity; they'd heard whispering, and they'd then heard footsteps

of someone walk into the bathroom when they'd both been sitting still. We told them that we might have had an actual ghost sighting with Tom seeing a figure, but that was followed by fifteen quiet minutes.

Given the activity that Rich and John had reported, we decided to stay on in the room for a while to see what would develop. It was a fairly large room so John sat on a sofa in the living area immediately inside the door to the room. Along the corridor was a large bathroom, which Tom and Rich sat in, and I went to the bedroom with a large four-poster bed.

Rich said loudly 'If there's a spirit here with us can you give us a sign?' We had immediate results with all four of us experiencing different things at almost exactly the same time; John heard heavy breathing next to him, Tom felt freezing cold, Rich heard a noise like someone tutting, and I heard a knock on, or in, the chest of draws in the bedroom.

Rich and Tom then asked at the same time if I'd moved as they'd heard a knock. I'd not moved but I heard it too, it seemed to come from the area of corridor between the bathroom and the bedroom.

Only a few seconds later Tom said 'quiet, I hear footsteps', I couldn't hear them but John said he could hear them too and said they sounded like they were outside the room on the landing.

The activity was coming at us thick and fast, and it was all audible stuff. It was so fast we could barely keep up with who was hearing what. Rich and I then heard footsteps in the corridor outside the bathroom, I felt like they were heading straight for me, then they stopped as immediately as they had appeared.

I was sat on the bed now, staring down the corridor, past the bathroom, towards the living area where John was sat. The only light was coming from beneath the door, and for the briefest of moments that light was blocked by something, prompting me to ask if John was moving around. He said he wasn't. We then all heard a loud bang which sounded like it was outside the door. Rich asked out for another bang, another sign that someone was with us. There was a knock from the room I was in, I span my head quickly and the sound seemed to come from a chair.

Rich and Tom in the bathroom of the Minster Suite, believed to be the haunt of a playful young girl.

John said he could hear a repetitive noise, and Rich jumped in and said he could hear it too and it was a bus idling outside and the sound was the engine ticking over. This puzzled me as I was closest to the window and I couldn't hear a thing. I walked over to the window and looked outside and the road beneath the window was empty; however, at that moment I heard a voice whisper in my ear, just one word and I didn't catch what it was, but it was definitely a female voice. It really shook me up, as I hadn't felt uncomfortable at all in the Golden Fleece. In fact, Rich had even passed comment when we first arrived that he'd felt extremely unwelcome at the Guildhall recently, and 35 Stonegate too, but he felt comfortable here. I had done, but now I wasn't too sure, one thing I was confident of was that we weren't alone, and whoever was there with us wanted us to know that we weren't. I told the others what I'd heard, and John said that the whispering that he and Rich had heard before Tom and I joined them had sounded female to him. Encouraged, but concerned, we pressed on, I sat back on the bed, but I was on edge and I was constantly scanning the room behind me.

The next ten minutes passed quietly, and we all felt the atmosphere in the room had lifted.

It was already midnight and we could hear the bar had emptied, but the cleaners had moved in to get the Fleece ready for the next day, so before we moved to the bar, we went to St Catherine's Room.

I volunteered to sit in the bathroom, which had previously been a hidden room, walled up for centuries, and I closed the door separating me from the others, who each sat on one of the single beds.

Again, as with every room we'd investigated so far we had an occurrence within minutes of entering; Rich said he heard, and felt, someone walk between the beds. He asked out 'is there anyone here with us, if so let us know?' There was a knock almost immediately and Tom and John both said that it seemed to come from inside, or behind, the wardrobe.

Rich asked for two definite knocks and we got two clear knocks in return. He asked for three knocks, and in response we got three knocks back in quick succession. This

The bedroom of the Minster Suite.

was stunning, not only did we seem to be in the presence of one, or more, spirits, but we seemed to be communicating with them.

Tom, forever the sceptic, said that it could be possible that the knocking might be cleaners. I opened the bathroom door and suggested that since we'd been getting knocks in immediate response to our requests, we should sit in silence for a few minutes; if the knocks continue then perhaps he is right, but if we could hear no knocking, and then when we asked again they began, that would prove to a degree that this is genuine paranormal activity. He agreed that it made sense. So we sat for four minutes and didn't hear a single noise.

Rich asked again for three knocks, and we got three knocks straight away. However, this time they weren't coming from the wardrobe, they were knocks on the door of the room, so loud, and so definite that John ran over to the door as we were all convinced it must be a member of staff, but when he opened the door no one was there.

We experienced five minutes of silence, and the knocking in response to our questions had stopped. I was about to suggest moving down to the bar, for we'd spent far longer in this room than we ever intended and it was approaching 12.45 a.m., but Rich spoke before I could and said quietly that he could hear movement coming from behind the wardrobe, actually in the wall.

We agreed to move on, but before we did Rich and John returned to the Minster Suite to position our night vision video camera in the bedroom and leave it recording in the empty room. As they were about to open the door to the Minster Suite they heard a loud bang from the staircase behind them. They turned to see Tom and I stood at the bottom of the flight of stairs, but they knew we'd not made the noise; it had come from right behind them on the staircase.

Once they returned the four of us went back into the Shambles Room which Tom and I had investigated earlier. The cleaners had finished by now, and the building was

St Catherine's Room.

almost silent. I say almost, as we could hear knocks, bangs, and clicks all around us, we tried in vain to pinpoint the source of the noise but we couldn't. The sounds seemed to be coming from inside the wall.

John asked if I had my phone out, I responded 'no why?' he said he saw a green light between me sat on the seat and the wardrobe and thought it was the light from my phone screen.

Rich and John moved into the bathroom, which Tom had earlier said he found creepy for reasons he couldn't quite put his finger on. Tom and I sat on the floor in the bedroom, and we were now in silence as the noises from the walls had seemed to stop. We agreed to move to the two bars, so John and Rich went to collect the locked-off camera and we moved on to the next location.

We moved on to the back bar, the Merchants Bar, which was fairly well lit with light coming from a small room behind the bar which had the light on, and a light above a table in an alcove which couldn't be turned off for safety reasons.

It was only now that we realised it was after 1.00 a.m. and since the cleaners had left we hadn't heard or seen anyone else in the pub. Rich joked that he might help himself to a free pint since there was no one around. I had Tom take my photograph with the skeleton sitting at the bar.

I had a wander up to the top bar on my own to see if there was any sign of the landlady, but there was no one there. I took a few photographs and went back to rejoin the others. By the time I'd returned they'd spread themselves around the bar and sat down to begin our next vigil. Tom pointed to a darkened corner to the right of the door to the beer garden and suggested I sit there.

I headed towards the corner; however, as I neared I slowed down as I noticed there was already something on the seat behind the table. I stopped completely, and in the darkness I tried to focus in on what it was, it looked like a pile of blankets, or curtains. Then I saw something that made my heart race and my blood run cold. My mouth fell open as I spotted a pair of eyes staring intently at me. My torch was in my back pocket so I backed away while fumbling for it and trying to work out what was going on. Rich was nearby so I quietly blurted out to him 'there's something there, there's two eyes!' He looked at me accusingly like I was joking, but my expression told him I wasn't. John and Tom asked what was wrong and I said quietly 'there's someone there'.

The four of us stood shoulder to shoulder, a safe distance from the table, shining our torches on this object beyond the table. John said 'hello?' very loudly, but whatever it was didn't move an inch. For whatever reason none of us moved any closer to him/her/it, and Rich bent down to look under the table. His face was pale with fear when he stood back up 'there's a pair of shoes' he said under his breath. This was all so bizarre, but, and to this day I don't know why, we didn't go over and speak to whoever was there, instead we went to the top bar to gather our thoughts.

As we walked to the top bar, the urinals in the gents' flushed loudly making Tom jump. When we got to the top bar we were all talking over each other as we were all equally confused and freaked out, I was beginning to wonder if the eyes we'd seen were from perhaps a Halloween mask left over from a few days earlier. Now I'd had a couple of minutes to sort my head out, I wanted to return and find out, but Rich said that now we were in the top bar we might as well see if we could stir up some activity

here, then we could return to the back bar. We were all happy with this and took a seat. I sat next to the window, looking out onto the now deserted streets. Rich asked for some kind of sign that we were not alone, but try as we might we didn't get any responses whatsoever to any requests we made.

It was 1.35 a.m. and it had been a long night, so I proposed that we take a short ten-minute break back at base, have a drink and review the footage from the Minster Suite on the night vision video camera. I clearly heard a woman's voice behind us as we climbed the staircase to the function room John who was behind me said that he heard it too. We stopped and looked back down the staircase but we couldn't see or hear anyone. Not long after getting back to base, we heard footsteps walk across the room above us, followed by a door open outside the room we were in, John rushed to the door and a woman dressed in black walked past him. He said 'hello' as she walked right past him, but she didn't acknowledge him or respond and she walked down the stairs. So we knew there were at least two other people with us in the Golden Fleece: the woman we'd heard downstairs, and the woman who'd just walked past us.

We had a drink while John and Rich watched the locked-off camera footage back but unfortunately it had captured nothing out of the ordinary.

It was time to return to the back bar for our final vigil. As soon as we entered the room I walked over to where I'd seen the 'eyes' earlier, but whoever it had been had now vanished, and taken their shoes with them. I also noticed the skeleton sitting at the bar was now nursing a double whisky, and despite being teetotal I could certainly use one after the evening we'd had.

We took a seat and before we'd even attempted to communicate with any spirits, we could all hear mumbling and it seemed to be coming from above us. Tom rationalised it was probably the landlady watching some television in an upstairs bedroom.

John asked for some kind of sign that we weren't alone, and as he spoke I spotted the text on a leaflet on the table at which I was sat. It declared 'The Golden Fleece, York; England's most haunted inn, come and see for yourself if you dare.'

Rich and Tom were both facing the corridor to the top bar and both asked if there were any machines switched on along the corridor. I was closest and responded that there wasn't anything turned on, or we'd have noticed when we'd been moving between the bars. They both described seeing square blocks of red light flashing and moving up and down.

Rich and I then suffered from some extreme temperature changes; we both felt freezing cold, but I suggested that it might be a draught running along the corridor from the top bar. However, within only a couple of minutes I was even colder, to the point where I was shivering and my teeth were chattering, but when I asked Rich how he felt, he said he was red hot, he felt like he was burning up.

Within ten minutes both Rich and I had thankfully returned to a comfortable temperature, but the paranormal activity kept on coming. Rich said he heard a woman's voice in the bar with us, he suggested that perhaps it was the landlady in the lit-up room behind the bar. Within seconds Tom said he'd seen a torch in the corridor coming towards us from the top bar, but then it had been clicked off. Were there two other people in the bar with us? John looked over the bar into the lit up room and said 'hello' with no response, and I walked up to the top bar. There was no one there.

A watch beeped the hour, and a quick check of my mobile phone confirmed it was 3.00 a.m. Our ghost hunt had come to an end and we were all shattered. We'd had an amazing night, and couldn't have possibly asked for any more from the Golden Fleece, it had definitely delivered. It was time to head back to the Cumbria House for some much deserved rest.

Well we'd like to leave but we couldn't get out! The front door to the pub was locked with a mortis lock. We'd have to find the landlady before we could get out so the four of us went to the only lit room in the building, the room behind the bar with 'Staff Only' written on the door. However, we knocked on the door and the room was empty.

I was drained; I just wanted my bed, so while the others frantically searched the building for our host I took a seat in the top bar and looked out onto the empty streets outside. I knew they'd not had any success when twenty minutes later, 3.25 a.m., I could hear Rich shouting 'Hello? Steph?' very, very loudly. Tom and John came to join me in the top bar, 'no joy?' I asked, already knowing the answer. Down the corridor Rich's shouting continued 'Hello? We'd like to leave now, but we're locked in the Golden Fleece!' Tom and John had taken a seat at the table with me by the time Rich appeared, having admitted defeat. Rich's shouting had been loud enough to wake the dead, and it was clear, very clear, that we were actually the only people in the Golden Fleece.

Rich sat down too, I checked the time and it was 3.35 a.m. I then sat bolt upright had a sudden realisation which made me, albeit briefly, forget all about our predicament; If we were the only people in the pub what was the mumbling we'd heard when we'd been in the back bar? What happened to the woman who'd walked past us, we'd all seen, and to whom had John said 'hello'? What about the 'eyes' in the back bar?

I was still considering these earth-shattering questions in my head when Rich said 'if we're still locked in here at 4.00 a.m. I'm going to have a free pint as 'compensation' for the farce we find ourselves in'. We weren't going to 'escape' by sitting in the bar, so I went for one last look around. I walked into the back bar, and tried the door to the beer garden – result, it opened. I shouted on the others and they came to see what I'd found. Tom held the door open while I went out to check we could get out into the street. There was a tight squeeze past a Land Rover parked tight to a wall, but beyond that was a large, open gate, and through the gate was freedom!

Five minutes later we were on our way back to the Cumbria House. We'd spent forty-five minutes more than planned in the Golden Fleece, which seemed determined to keep us locked away from the world outside.

At 4.15 a.m. we finally got to bed, and as soon as my head hit the pillow I fell asleep. When I was awoken it seemed like only five minutes had passed, but it was actually 8.30 a.m. John went for breakfast while the rest of us tried to get a little bit more sleep. As Rich and I discussed our adventure drawing to a close between Tom's snores, a plastic cup on the chair next to John's bed fell on the floor – perhaps it was a draught, or perhaps it was the little Victorian girl of the Cumbria House giving us one last reminder of just how haunted York really is.

We left at 10.00 a.m. having had a chat with Tom and Elaine, and thanking them for their hospitality. It was time to say goodbye to York, and our adventure.

We'd dared to take on Haunted York, and we'd survived to fight another day.

CONCLUSION

IN THE END

York was incredible. Despite Andy finding our first investigation at the National Railway Museum too intense and calling time on his ghost hunting days shortly afterwards, Rich, Tom, John and I shared in the adventure of a lifetime. This epic journey of discovery will live long in the memory, and I expect we'll still be enthusiastically reminiscing for decades to come about ten of the most amazing nights we could have ever hoped for.

Looking back upon the ten investigations, are we now any closer to answering the big question: Do ghosts exist?

All four of us all had inexplicable paranormal experiences, both shared and individual, far too numerous to list, including Rich's panic on the bridge at NRM, three of us being prodded by an unwelcoming spirit at the York Dungeon, Rich actually seeing a ghost at Middlethorpe Hall Hotel, countless bangs, knocks, voices, footsteps and cold breezes, and of course that unbelievable EVP from the York Tyburn. When all this is taken into consideration we're undeniably closer to the proof we set out to find.

Coincidentally as I write this a little over a week after our final investigation at the Golden Fleece, an email that Rich sent to Tom, John and I has literally just dropped into my inbox and reads:

> *I don't know if it's me being paranoid or what, but I had a weird feeling all the way back home after the Golden Fleece. I genuinely thought I'd brought something back with me.*
>
> *What really freaked me out was that the first night after we got back, Amy woke me up in the middle of the night saying she'd heard movement around the bed and that there was a rustling/whispering in the air she couldn't find the source of (I couldn't hear it). That happened for a couple of nights. It was really strange. I didn't want to go into the bedroom for a few nights after that.*
>
> *It's OK now, the usual warm empty feeling has returned but it was sooooo bizarre for a short while. The thing that worried me the most was that I didn't mention anything to Amy about feeling like something had come back. When she mentioned it, I was all ready to get the place exorcised …*

We're definitely getting closer, of that there's little doubt, but our search will continue until we find definite, absolutely conclusive evidence. Perhaps we'll find the answers we seek in Edinburgh …